NANTWICH
THROUGH TIME
Paul Hurley

AMBERLEY PUBLISHING

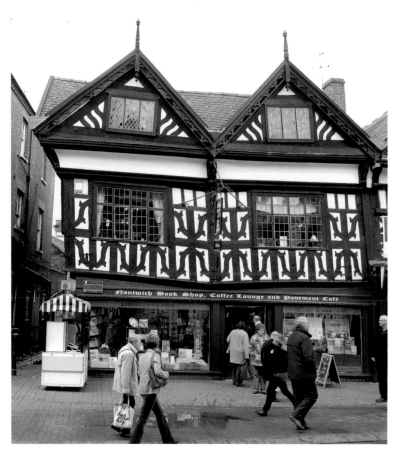

This ancient shop was built soon after 1583 replacing an earlier one lost in the Great Fire, little has changed over the years and it now houses the Nantwich Bookshop and tearooms.

First published 2010

Amberley Publishing Plc
Cirencester Road, Chalford,
Stroud, Gloucestershire, GL6 8PE

www.amberley-books.com

Copyright © Paul Hurley, 2010

The right of Paul Hurley to be identified as the Author of this work has been asserted in accordance with the Copyrights, Designs and Patents Act 1988.

ISBN 978 1 4456 0065 9

British Library Cataloguing in Publication Data.
A catalogue record for this book is available from the British Library.

Typeset in 9.5pt on 12pt Celeste.
Typesetting by Amberley Publishing.
Printed in the UK.

Introduction

With a county as beautiful as Cheshire, it is hard to pick out an area of special mention but if one were to be nominated it would be Nantwich. It has the largest number of listed buildings in the county outside Chester. The streets are lined with ancient black and white and red brick buildings of considerable antiquity, most were built after the Great Fire of Nantwich in 1583. This devastating fire was started by a man called Nicholas Brown brewing beer in Water Lode near to the river. Fortunately nothing across the river on the Welsh Row side was damaged and in the other direction, the fire stopped just before it reached Sweetbriar Hall in Hospital Street. This also saved that other Nantwich jewel, Churches Mansions. This is not a book to go into historical fact too deeply but it would be remiss of me not to comment upon the historical gem that is Nantwich.

It has been a very important town from the earliest days, it is the oldest of the three Cheshire wiches or wyches from which salt has been drawn, the other two being Northwich and Middlewich. During Roman times Nantwich was famous for the salt that was mined here, Welsh Row being so named as it is the road that the Welsh used to enter the town to collect salt. In fact its ancient name was *Helath Wen* (the town of white salt) the present name is derived from Nant meaning Vale and Wich, a salt spring. Other names for the town have been *Wich-Malbank* after the ancient family of Malbank whose ancestor was one of Hugh Lupus's relations and *Namptwyche*.

Salt had been drawn from Roman times with a break during the wars with the Welsh when Henry III had the brine pits filled up to stop the Welsh getting it as they had done on a large scale before that. When peace with the Welsh was declared the pits were opened and back in business, during the reign of Henry VIII there were some 300 salt works. But by the mid 1800s the trade had declined, the last salt house closed in 1856.

Salt was not all that the town was famous for. It was an important town during the English Civil War when it was held by Parliamentarians at a time when most of Cheshire supported the Royalists. Because of this the town was put to a siege and an attempt was made to burn it down once again. After a fierce battle at Acton the siege was lifted on 25 January 1644 on a day that was thereafter called Holly Holyday and this was celebrated in the town for many years thereafter with much festivity and the wearing of holly sprigs in the hair, the Sealed Knot Society still re-enact the battle on the anniversary of the Acton rout named The Battle of Nantwich.

In this book we look at Nantwich through the years, the earliest photograph is of the Market Hall in 1860 and with more than 100 listed buildings in this small town there is a lot to see. Take a walk along the streets, from Barony Road to London Road and down the ancient Hospital Street into the town proper where the streets are set out in a medieval pattern. Take a look down Pillory Street, the home of the excellent Nantwich Museum and art gallery and then continue down High Street to Water Lode. Cross the old stone bridge and continue along Welsh Row to the aqueduct and through to the village of Acton. As you go take the short detours to seek out other photographed areas of this lovely town and see how they have changed over the years.

People born within the sound of St Mary's bells are called Dabbers as is the football team, a Nantwich name, the origin of which seems to be lost in the mists of time. It probably originates somewhere in the broad Cheshire dialect that is spoken here by long standing Dabbers!

Years of being laid to waste during the Norman Conquest, frequently bashed by the Welsh, set on fire, placed under siege in the Civil War and plagued by plagues has left a small and pretty town steeped in history. Unlike other towns, the usual town planning vandalism has, with exceptions, been kept to a minimum leaving this historical town as we see it today. Buildings like the unusual Chester's/Christians building at the Hospital Street junction was a good swap for the old building that it replaced. So peruse this book and peruse it again, each time you do you will see something different. Enjoy it as I have enjoyed compiling it.

Acknowledgements

The majority of the old photographs in this book have been provided by Kevin Greener from his archives. All images are available individually in photograph format from The Picture House, Nantwich Market Hall, (email kevindgreener@yahoo.co.uk). Kevin would like me to thank all of those people who over the years have kindly provided photographs for his archive especially Robin and Janet Gray, Robin is sadly no longer with us but his legacy lives on. Accordingly I would like to thank Kevin most sincerely for both the loan of the photographs and his advice and counsel as his knowledge of old Nantwich really is second to none. I would also like to thank Jean Smith for passing on her knowledge of the town and Anne Wheeler the curator of the Nantwich Museum and her staff for a truly excellent museum. Also thanks to Jon Winkle of the Cheshire East Council for providing the Brine Baths photograph and John Grocott of Nantwich Fire Station for his loan of a photograph and advice. Finally a debt of gratitude is owed to my wife Rose for her understanding during the trips to Nantwich in the hope that the sky would still be blue when we got there, her assistance on the many town walks camera in hand! And then when I spent many weeks working on the book.

About the Author

Paul Hurley is a freelance writer and member of The Society of Authors. He has a novel, newspaper, magazine and book credits to his name and lives in Winsford, Cheshire with his wife, he has two sons and two daughters.

By the same author
Fiction
Liverpool Soldier
Non-Fiction
Middlewich
Northwich Through Time
Winsford Through Time
Villages of Mid Cheshire Through Time
Frodsham and Helsby Through Time

www.paul-hurley.co.uk
paul@hurleyp.freeserve.co.uk

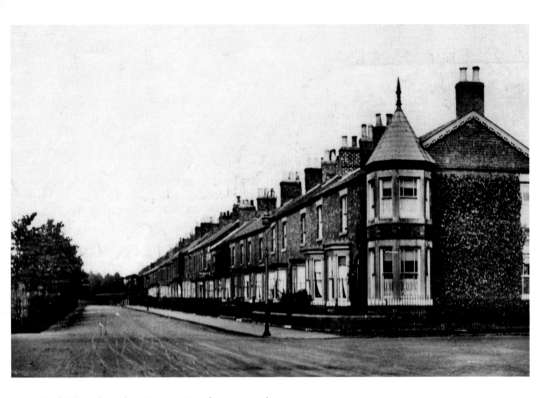

Park View junction Barony Road 1900s and 2010
Little change here for this early 1900s row of red brick houses that stand at the junction with Beam Street, Barony Road, Millstone Lane and Park View that we look into. Opposite the houses is the park and sports area known in 1902 as Beam Heath. The ivy has been removed from the gable end on the first house that boasts a large corner bay allowing a view down Millstone Lane.

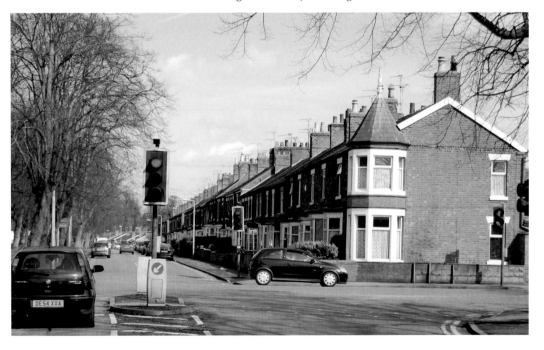

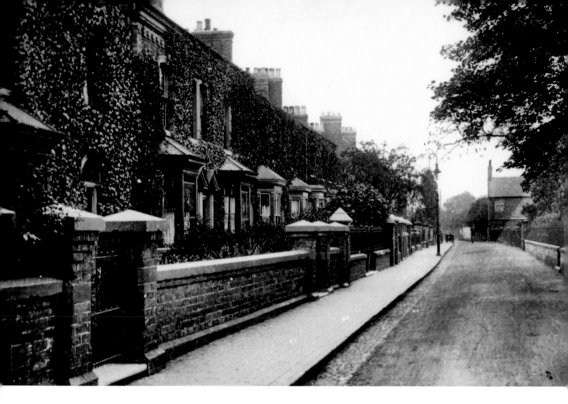

South Crofts undated and 2010

These cosy houses comprising South Crofts were once known simply as Crofts. They now comprise South Crofts and North Croft. An interesting then and now photograph as the house with the hip roof is just on the extreme left and if you look at the sandstone cap on the second gate post you will see that two chips in the sandstone are in both shots.

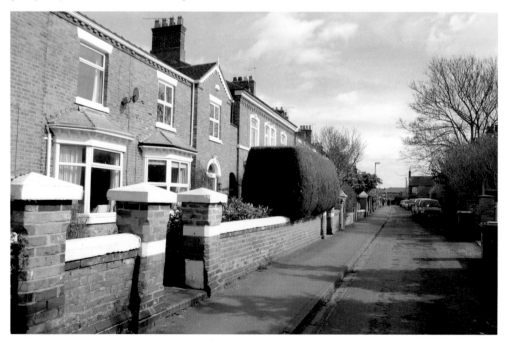

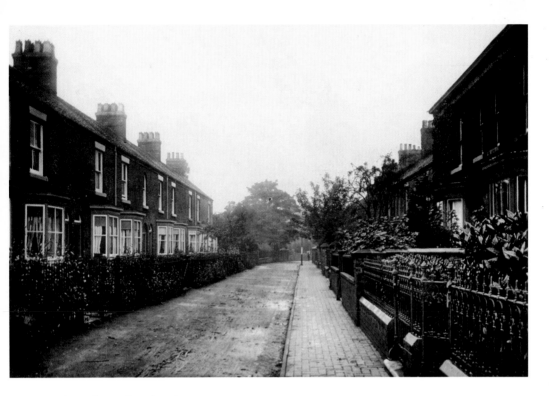

South Crofts undated and 2010

We now walk up the road and look back, little has changed other than the predominance of cars and the smart cast iron railings on the right have gone, probably to aid the war effort. Some of the bay windows have gone and the old sashes have been replaced with UPVC.

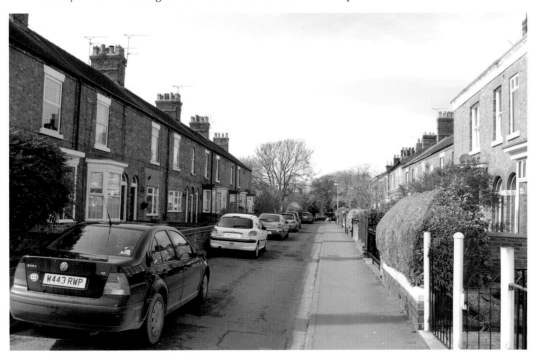

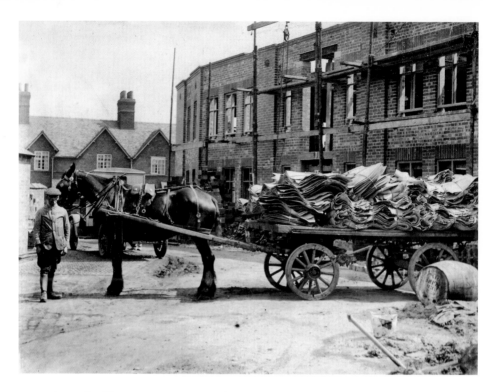

Tanner's yard Millstone Lane 1920s and 2010 with inset
What an atmospheric photograph of a bygone way of life. The horse and dray with their
driver stands in the yard of Harvey and Sons. Leather is stacked on the dray and behind it
can be seen a period motor lorry. The building on the right matches the row of houses in
Millstone Lane that can still be seen; it appears that work or demolition is being carried out
on these buildings. They have now gone to make way for the modern block seen in the inset.
I have included the row of houses in the modern shot as they match the old photograph.

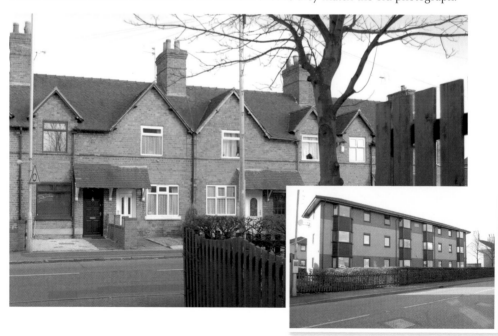

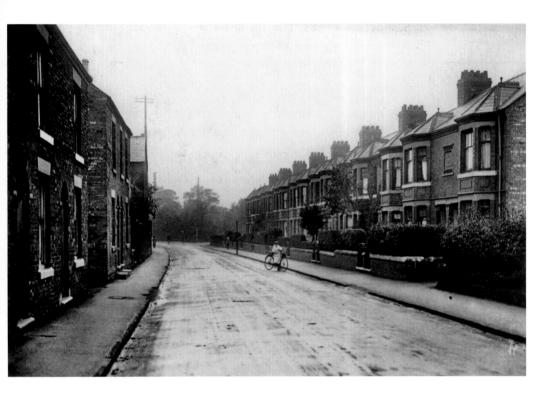

Crewe Road 1920s and 2010

Onward now for a view down Crewe Road towards the small roundabout in Millstone Lane, a row of red brick terraced houses stretches down on the right. These were built in 1909 and the first one has a plaque with the name Alexandra Villas on the front elevation. The modern photograph was taken from outside the now boarded up Cheshire Cheese pub.

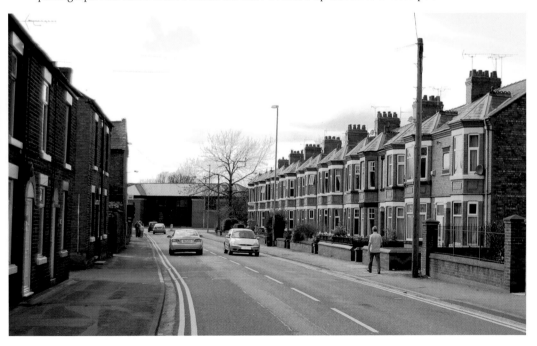

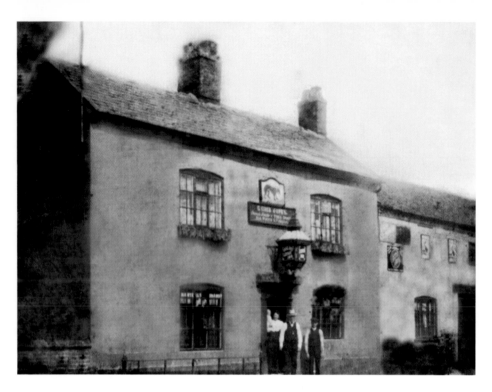

The Leopard Inn, Chester Road 1800s and 2010
The old photograph shows the inn as it looked before being re-built and in 1880 the landlord was Thomas Lovatt who was also the Deputy Clerk to the Nantwich Union. By 1906 the pub had as its landlord Jones Gomer who, as well as being a licensed victualler, was a manufacturer of mineral water and a furniture remover!

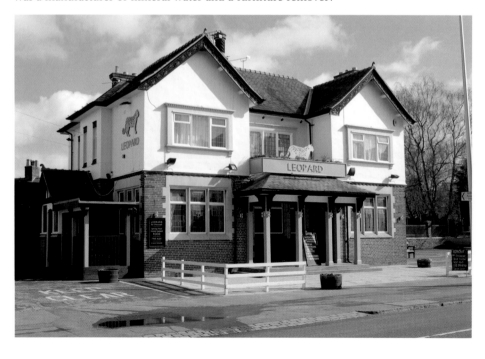

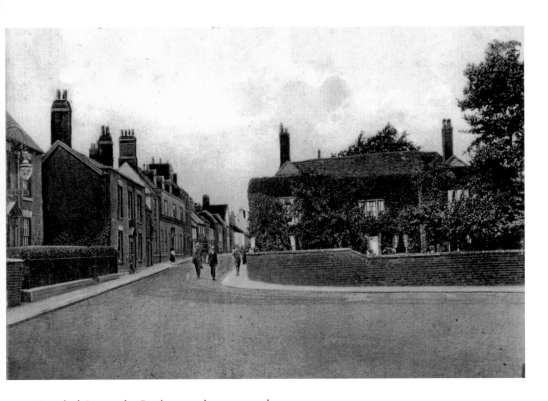

Hospital Street the Rookery early 1900s and 2010

Looking now from London Road and the roundabout opposite Churches Mansions into Hospital Street with the large house in the foreground, this was known as The Rookery and was number 1 Millstone Lane. The resident in 1906 was Edwin Dutton Elliot, a gentleman. The white house on the left is on the site of St Nicholas Hospice established in 1083 and the present house incorporates a sixteenth-century dwelling and the birthplace of Randulf Crewe, Lord Chief Justice in 1625. The hospice is believed to have given the street its name.

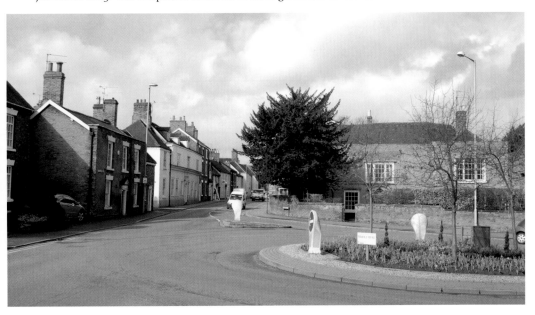

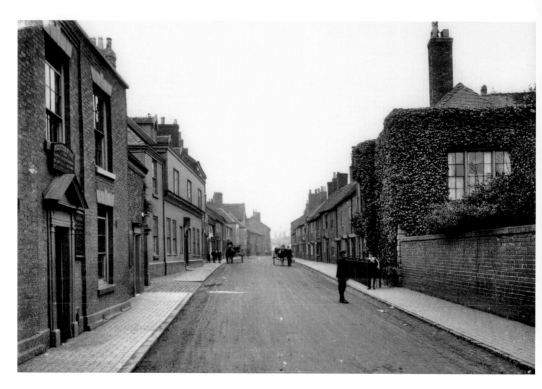

Hospital Street Registrars early 1900s and 2010

The young boy in the old photograph stands with his back to the registrar's office for Nantwich. In 1906 the superintendent registrar was John V. Speakman who also held the post of Magistrates' Clerk for the town, Joseph Bellyse was the solicitor. Note the heavy growth of ivy on the sidewall of The Rookery.

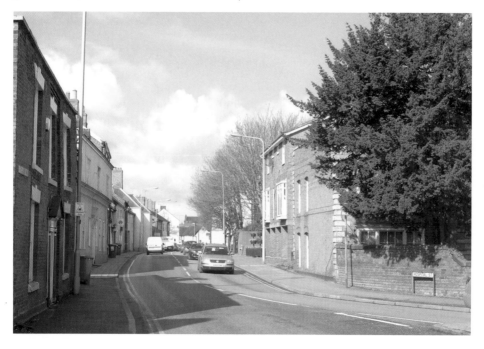

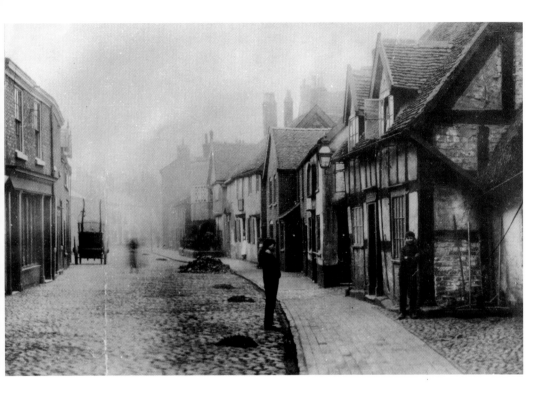

Hospital Street The Gullet pre 1893 and 2010

Now we have a look at the changes in this area over the years. In the old photograph we see a boy standing on the cobbles. The other boy is by the row of old buildings. Look carefully at this the first of the photographs of these buildings and see that in this shot The Gullet is between the cottage with the two roof windows and the next one down. Sweetbriar Hall can be seen in the distance.

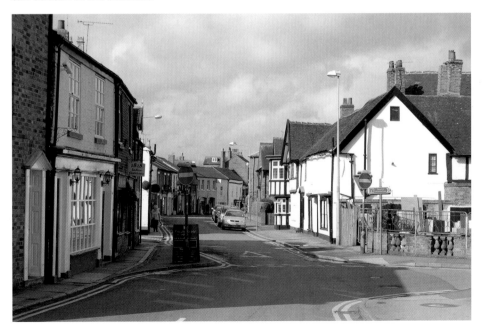

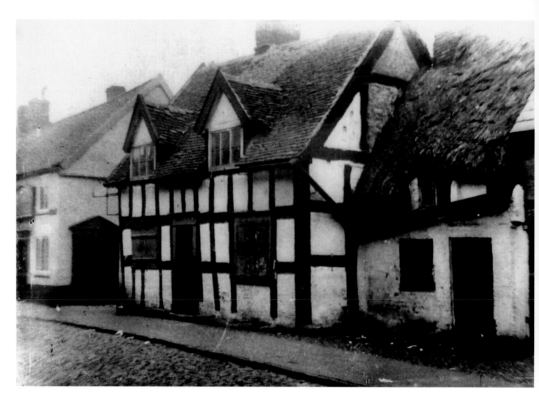

Old Houses Hospital Street pre 1893 and 2010
We now have a more detailed and older look at the cottage with the roof windows and the small thatched barn next door, both the cottage and the barn were the first to go to make way for the next photograph which is of the Globe Works.

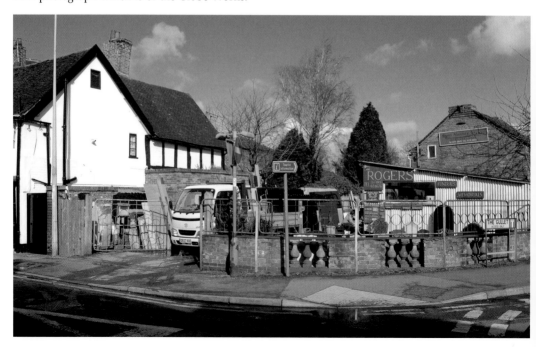

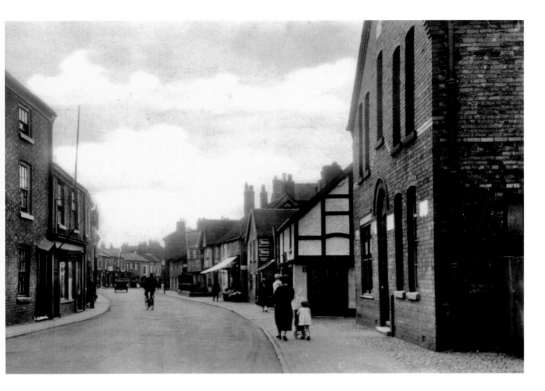

Hospital Street Globe Works 1931 and 2010

The large white building on the right has a plaque on the front elevation reading Globe Works 1893. The old photograph was taken in 1931 when the building was in a far more attractive condition. The cottage with its barn has gone but the other buildings on the other side of the narrow gullet are still there. In the modern photograph all of the buildings up to the large white one have been swept away and a stonemason's yard now graces the scene.

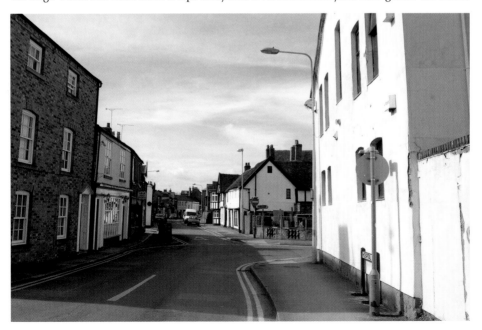

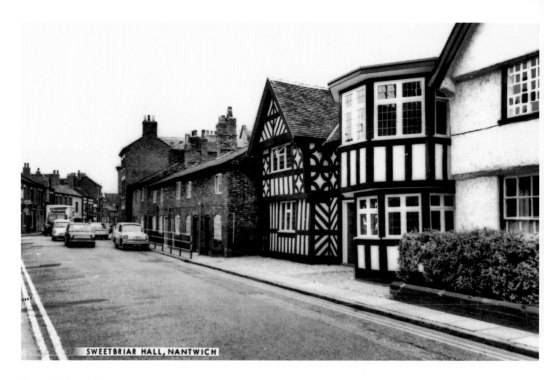

SWEETBRIAR HALL, NANTWICH

Sweetbriar Hall 1960s and 2010
Over the years the building saw changes in its fabric, the railings were removed probably for the war effort and during the '40s and '50s it was allowed to fall into a somewhat neglected state. Accordingly a full refurbishment was carried out by the architect James Edleston leaving the building that we see today.

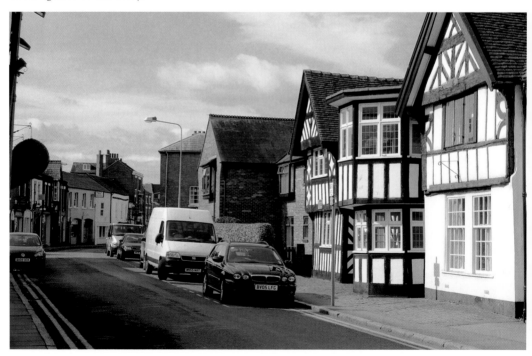

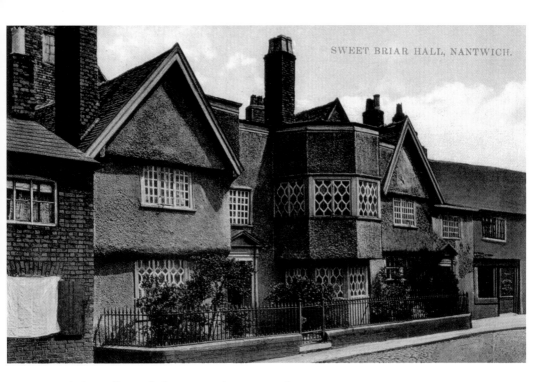

Sweetbriar Hall Hospital Street early 1900s and 1950s
Sweetbriar Hall was built before the Great Fire of 1583 for the Wilbraham family and later the birthplace of Sir William Bowman, noted surgeon and one of the greatest investigative doctors of the nineteenth century. The fire of 1583 took the house next to the hall but finally ended its devastation there saving the hall and other notable buildings. A timber framed building, built around 1450 it was later rendered and pebble dashed as can be seen in the old early twentieth century photograph.

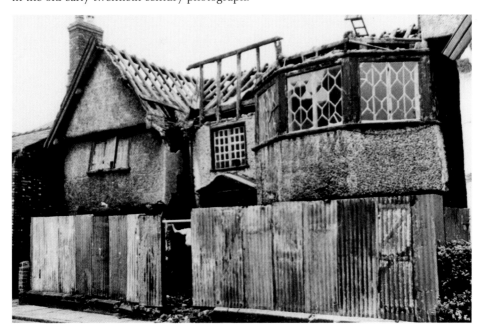

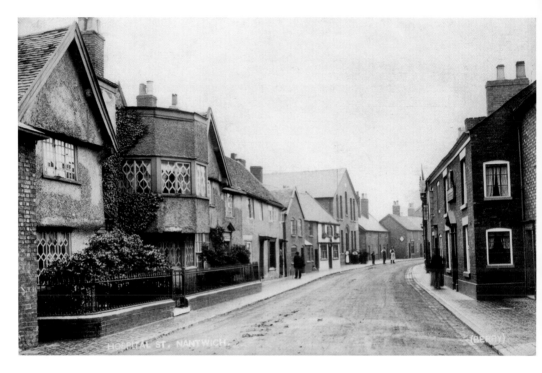

Sweetbriar Hall 1920s and 2010

A last look at Sweetbriar Hall before continuing along Hospital Street, the old photograph is later now and we look towards the Whitchurch end of Hospital Street. The staff from the Globe Works that we see in the distance have come out for a chat or to watch the cameraman, a sight common now but more than likely for a smoke break!

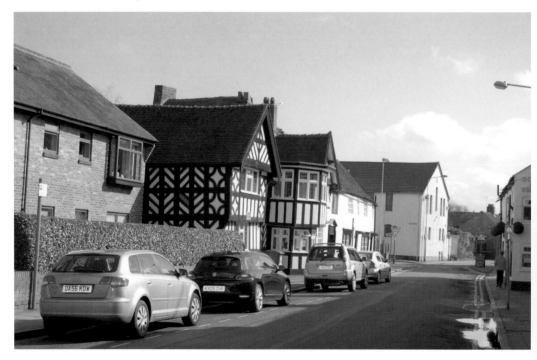

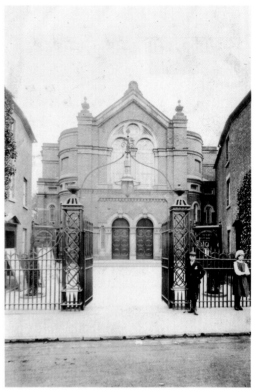

Hospital Street Methodist chapel undated and 2010

Carrying on along Hospital Street we come to the Wesleyan Methodist chapel, built in 1808 on the site of an old inn. The original chapel in Barker Street had grown too small for the growing congregation, in that chapel John Wesley preached on a few occasions. The present façade was erected in 1877 when the chapel was enlarged at a cost of around £2,000 and by 1902 the superintendent was the Revd. Edward Sinzinine with the Revd. Henry Babb. In 1908 the Wesleyan Methodist schools were built across the road.

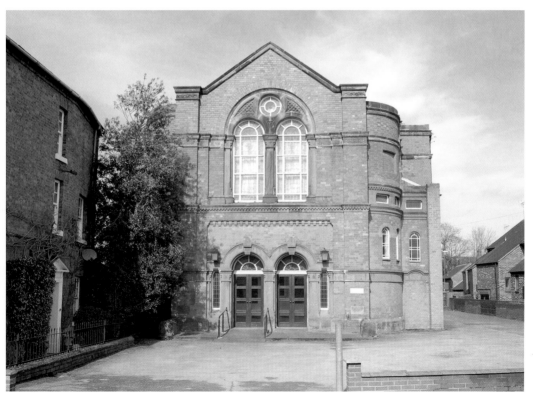

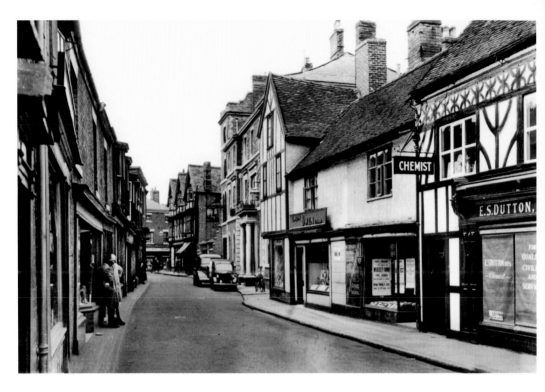

Hospital Street 2010 and 1950s
This period shot of 1950s Nantwich shows how little things have changed in this area, the lower part of Hospital Street. In the 1950s the road was wider but permitted two-way traffic.

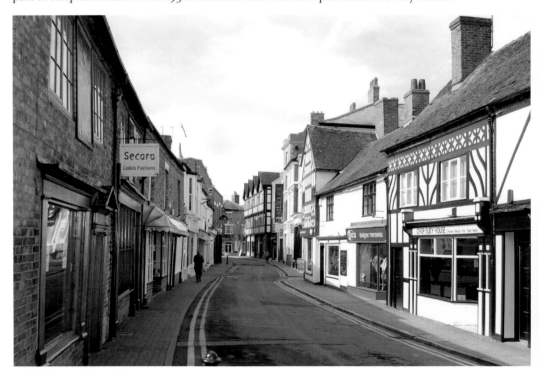

CHARLES GARNER,

The Popular Motor & Cycle Engineer

WELSH ROW & HOSPITAL ST., NANTWICH,

Is now one of the largest purchasing Agents in the North of England of the very best makes of up-to-date Cycles, including

HUMBERS, ROYAL ENFIELDS, SUNBEAMS, ELSWICKS, and RUDGE-WHITWORTHS.

The N.S.U. Motor Cycles, AND

Humber-Argyle & Gladiator Motor Cars

NEW AND SECONDHAND.

Motor Repairs a speciality. Spare Parts. Accessories. Petrol and Garage for 50 Cars. Tyres Vulcanised.

CARS FOR HIRE. *Official Repairer to the Automobile Club.*

Hospital Street 1906 and 2010
A similar shot to the last but including more period traffic, I have included a 1902 advert here as the 2010 photograph covers both shots. Later on we will see what the large building at the end on the right replaced.

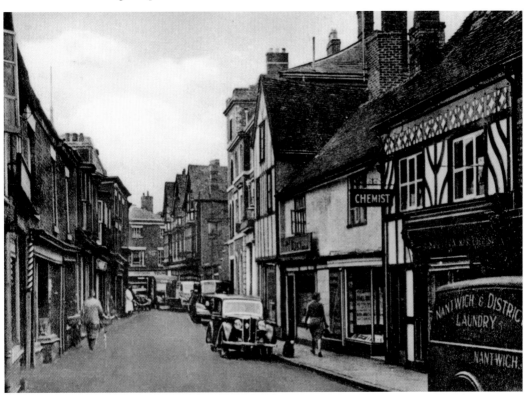

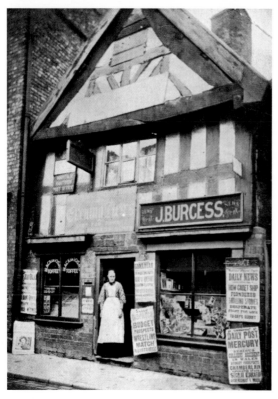

Hospital Street J. Burgess Newsagent's early 1900s and 2010
A well-stocked newsagent shop and sub post office owned by the Burgess family and situated in an ancient shop positioned between larger buildings. Eventually the need for re-development arose and the shop was demolished, it is now the entrance to Cocoa Yard. On the front wall is the VR logo. In 1906 John Burgess is shown as newsagent at 36 Hospital Street.

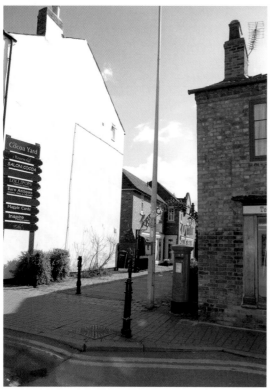

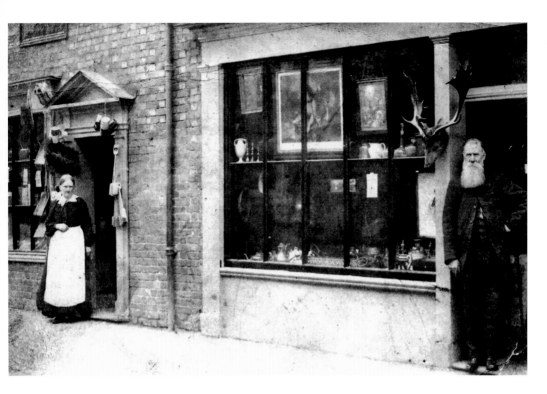

Hospital Street Antique Shop undated and 2010

These two shops were to the right of the Burgess Newsagent shop on the last page and show that very little has changed over the period. Both still look similar in the then and now shots albeit that the modern shops have been well refurbished after the two old people moved on. Again, hard to date but in 1934 Joseph W. Adams Antique Dealer occupied number 34 Hospital Street.

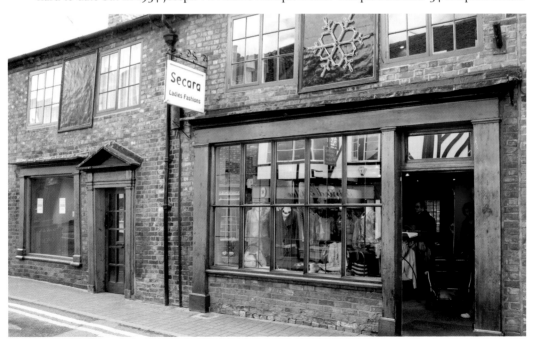

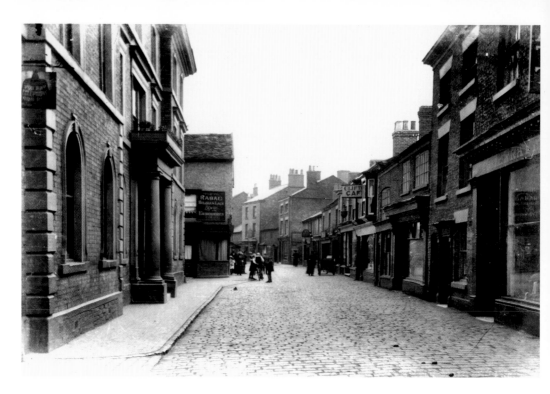

Hospital Street Lamb 1890s and 2010

We now walk to the end of Hospital Street and look back at the Lamb Inn or Chatterton House as it is called. In the 1800s it was known simply as Lamb Family & Commercial Hotel. It's no longer a hotel as it was converted to apartments, shops and a restaurant in 2004 after a long period of neglect. An inn has stood on this site since around 1554 and was the headquarters of the Parliamentary troops during the English Civil War. Nantwich was an extremely important town during the Civil War and in mainly Royalist Cheshire it leaned towards the Parliamentary cause.

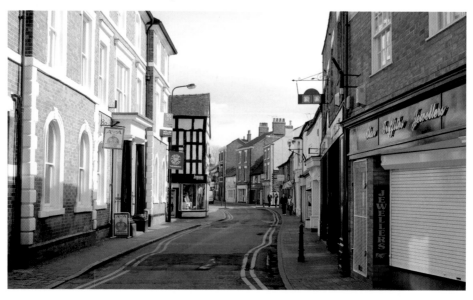

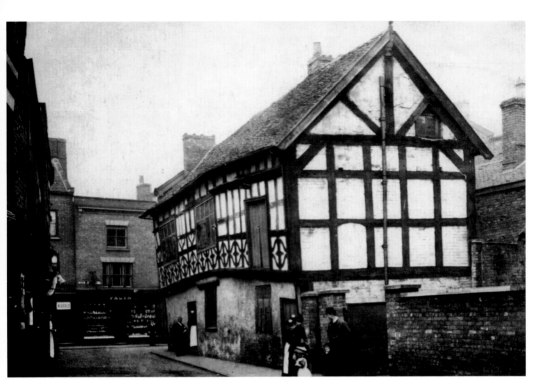

Hospital Street Garnett's Corner 1800s and 2010

Looking down Hospital Street into High Street we see the building that was on the corner plot on the right. It was known as Garnett's Corner and was cleared to make way for the large shop that was to house Edward R. Pooley draper's which can be seen on the next set of photographs. This in turn was renewed as the later photographs show.

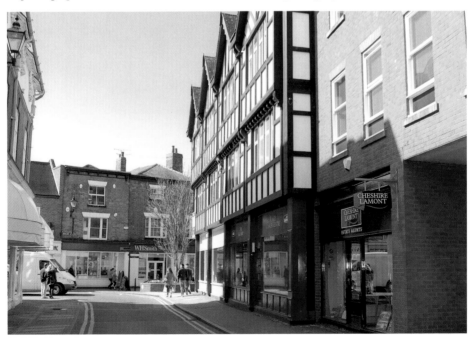

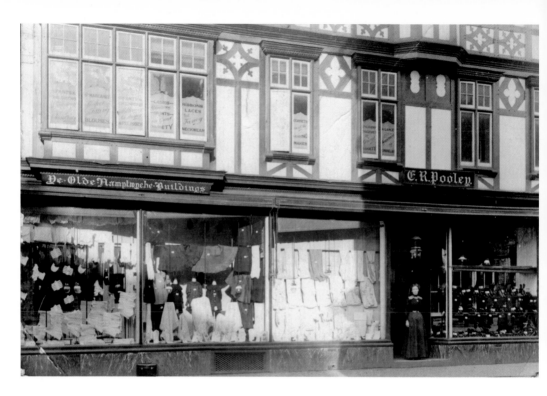

Hospital Street corner 1900s and 2010

The last ancient building has now gone and been replaced with a large draper's store owned by Edward Pooley. Garnett's Corner has now become Ye Olde Namptwyche Buildings as can be seen on the sign at the front. This building would receive some refurbishment later on to leave what we can now see in the new photograph.

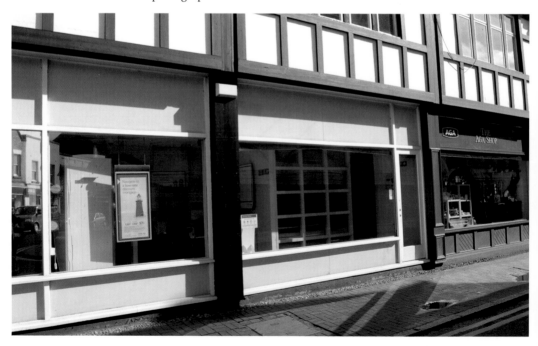

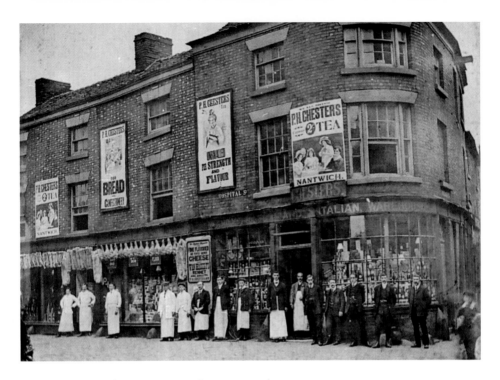

Chester's Hospital Street 1901 and 2010

We now turn to look at the opposite corner at what is now a 'wedding cake' of a building housing Clive Christian's luxury furniture company. But when the old photograph was taken around 1901 the building had only nine years of its old life left, in 1910 it would be demolished and the road widened. The new building, built in 1911 was not to everyone's taste and was designed by local architects Bower and Edleston. Whatever the locals said at the time of construction, this has to be described as a beautiful building and asset to the town.

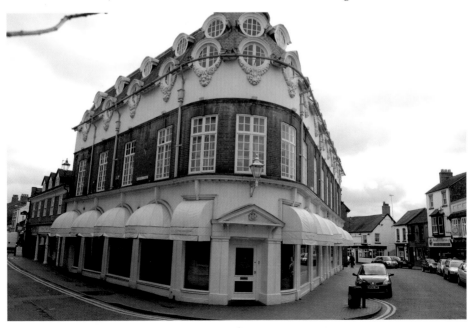

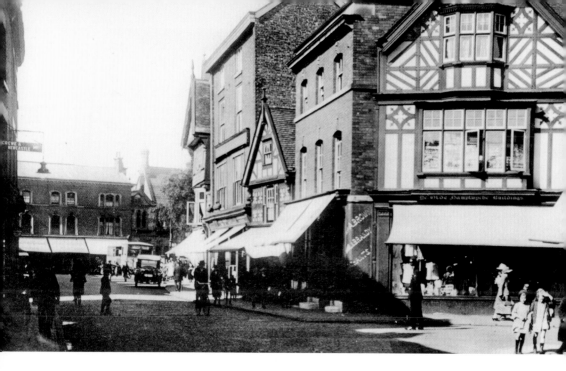

Hospital Street High Street 1920s and 2010

A look now towards No 1 Hospital Street to see the transformation that was carried out to bring it to what we have today. The new photograph shows that the front elevation has been drastically altered but in keeping with the surrounding buildings.

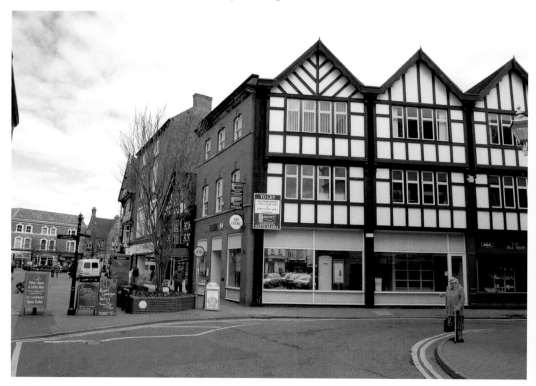

Hospital Street 1923 and 2010

One last look into Hospital Street from High Street showing again this unusual building that replaced the old Chester's building and did in fact house Chester's store for some time as the old advert from 1935 shows.

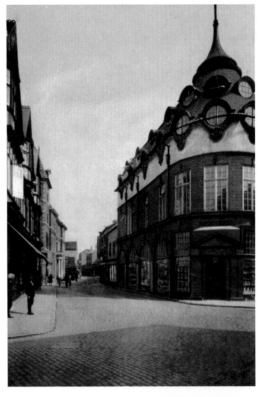

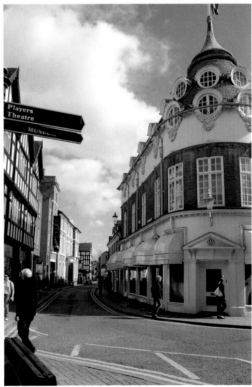

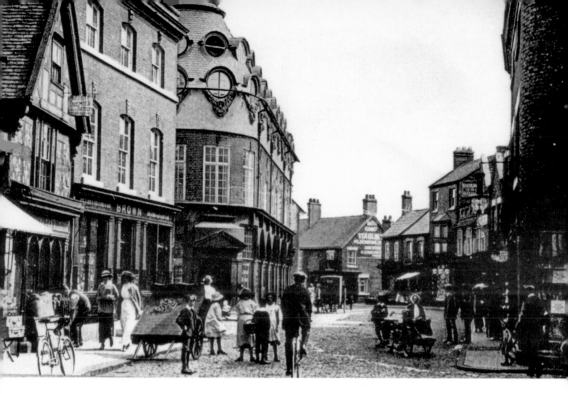

Pillory Street 1910 to 1920s and 2010

Now standing with our back to the Town Square we look into Pillory Street with the quite new building on the corner and the White Horse pub in the distance. The long established company of G. F. & A. & Sons Wine and Spirit Merchants are just before the Hospital Street junction at the end of High Street.

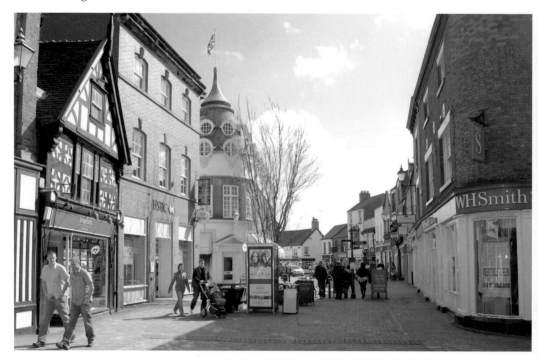

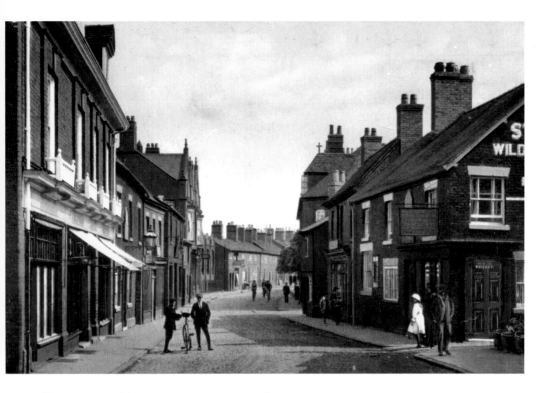

Pillory Street White Horse 1910 to 1920 and 2010
Another view down Pillory Street past the White Horse pub, this time the old photograph is coloured, a popular product at the time when photographs were hand painted over the sepia and sold as postcards. The stocks that give the street its name can be found opposite the museum.

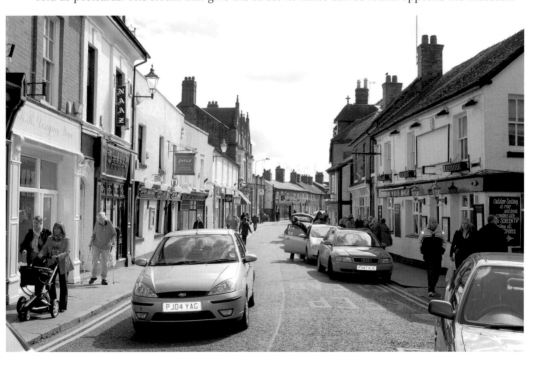

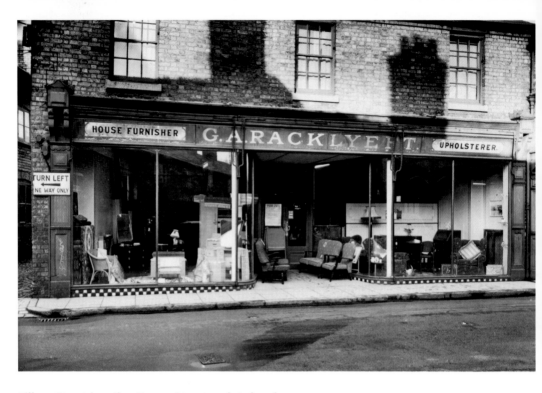

Pillory Street junction Queen Street undated and 2010

This old furniture shop stood at the junction with Queen Street, a street that is no more but that local people want re-instating. It is just down from the White Horse pub and on the same side as the museum. The Keep Left sign is meant for the traffic leaving Love Lane opposite.

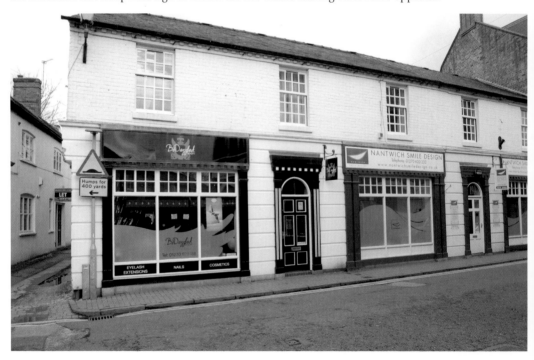

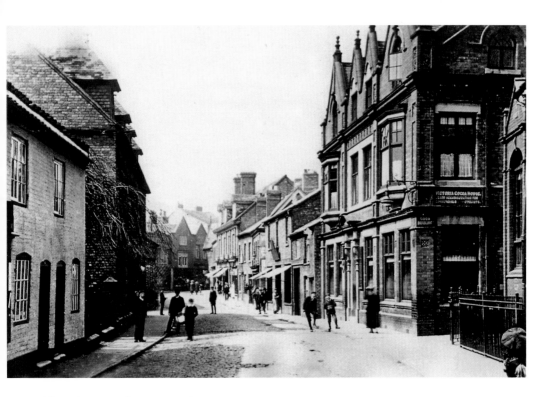

Pillory Street early 1900s and 2010

A walk into Pillory Street brings us to the Nantwich Museum and like the photographer at the turn of the last century I have taken a photograph back towards the White Horse. The large red brick building on the right in the old photograph is the Victoria Cocoa House where good accommodation could be had for commercials and cyclists. The museum was then Nantwich Library and now as the museum is a jewel in the already bejeweled crown of Nantwich! Unfortunately the blue Ferrari does not belong to the photographer!

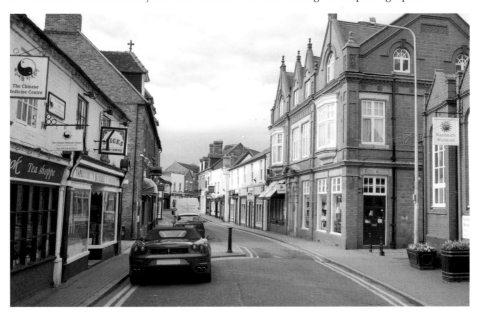

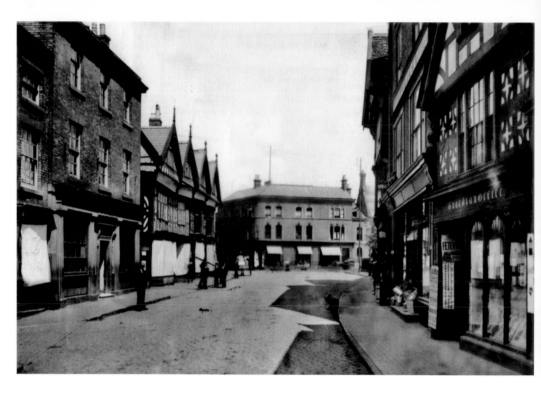

The Square with covered windows 1920s and 2010

Now back into High Street we look into the Town Square with the *Guardian* office at number 45 High Street on the right. It must have been a warm day as protective blinds cover the shop windows and there is also a dearth of passenger transport at the bus stop on the Square.

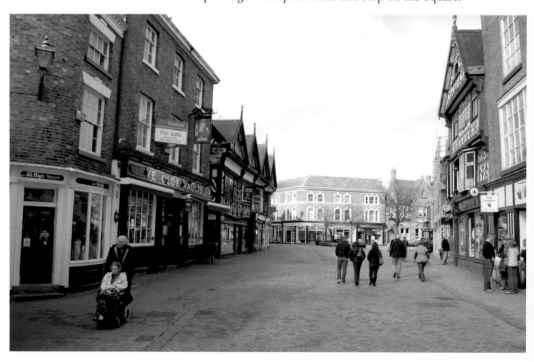

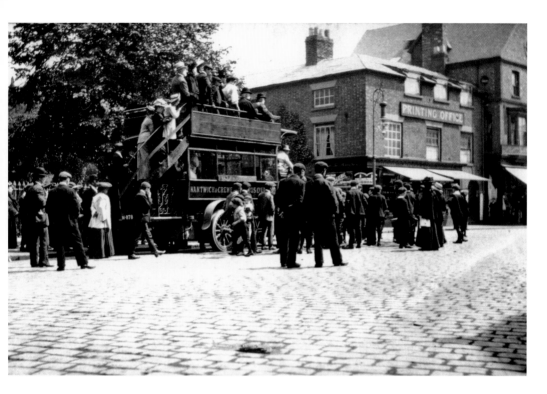

The Square 1915 and 1920s

Two photographs now of the same scene but showing the transformation of the WHSmith book store. In the 1915 photograph the building with the large sign on the front elevation saying 'Printing Office' is square and a bit boring. In the later photograph it has been re-built in the black and white style. The building next door is Lawton Brothers, Draper's at number 39 High Street.

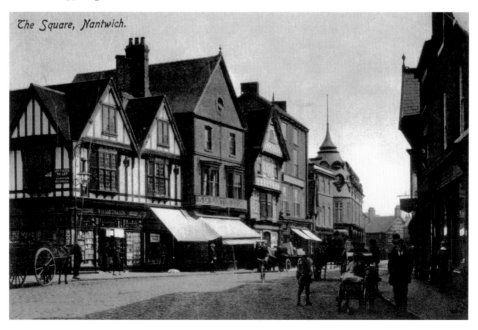

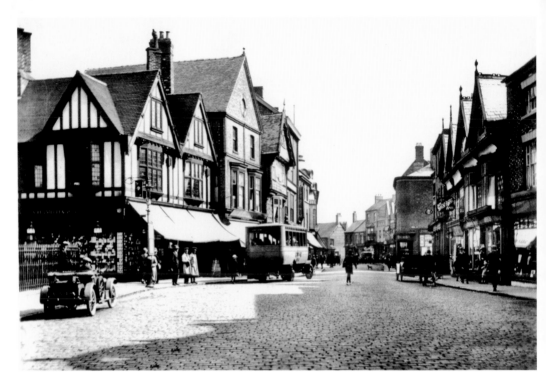

The Square 1915 to 1925 and 2010
A look at the square now with a modern photograph for comparison, unfortunately WHSmiths is again being re-furbished and is shrouded with a big yellow curtain over the scaffold. The area has changed very little over the period. Later photographs will show that it became a very busy road through the town centre until it was pedestrianised in 1983.

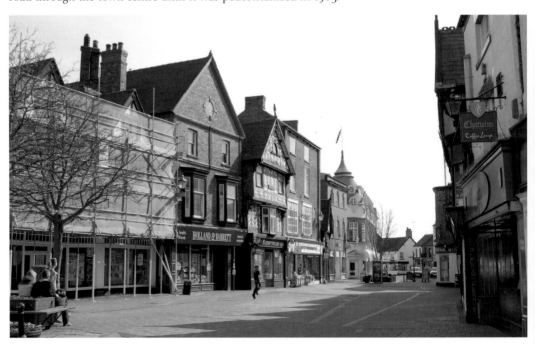

Market Square 1905 and 2010
The group of well-dressed school children are standing in front of 'Queens Aid House' or 41 High Street. The front of the building which was built after the fire in 1584 has an inscription thanking the queen for her aid in re-building the town. 'GOD GRANTE OVR RAYAL QVEEN IN ENGLAND LONGE TO RAIGN FOR SHE HATH PVT HER HELPING HAND TO BUILD THIS TOWN AGAIN'. There is also a tribute to the builder, after the great fire of Nantwich in 1583. Queen Elizabeth I gave, some say, £1,000 and some say £2,000 towards the re-building. Non-Conformist preacher Mathew Henry died here whilst stopping for the night on his journey from Chester to London in 1714.

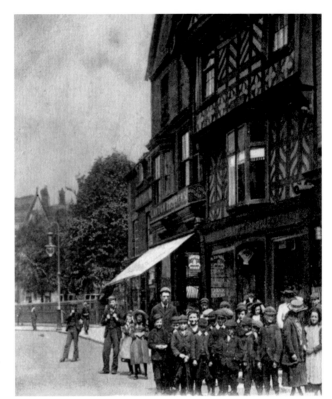

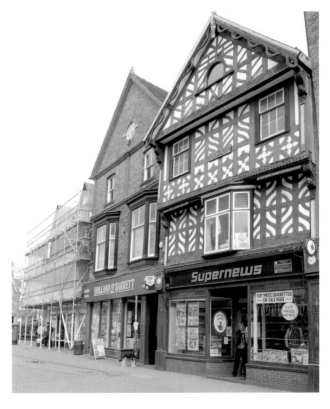

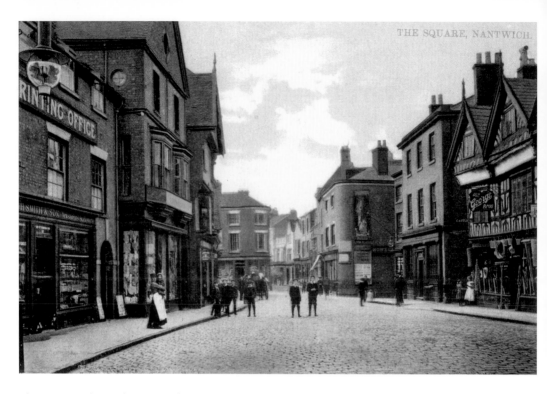

The Square Chester's 1900 and 2010

A look back towards Pillory Street at the beginning of the last century, WHSmiths has yet to be remodelled and the old Chester's store is still extant. George Brother's ironmonger's can be seen at 46 High Street.

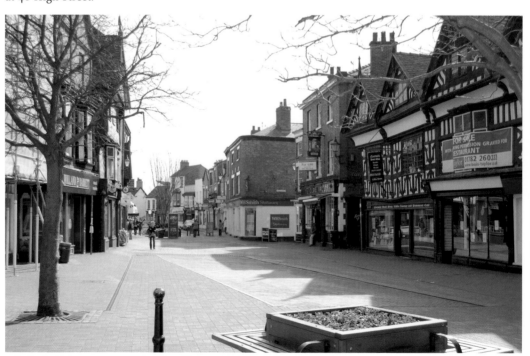

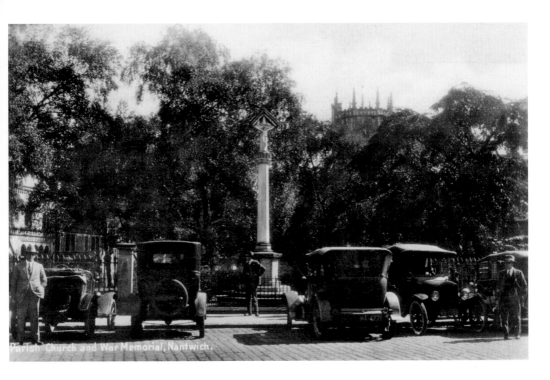

Parish Church and War Memorial, Nantwich.

War Memorial 1920s and 2010

The Nantwich war memorial sits on an area that has been pedestrianised and surrounded by benches and flowers. It was unveiled in 1921 by Lieut. General Sir Beauvoir de Lisle and shortly afterwards the old photograph was taken. There is a nice selection of period cars, and in the new photograph more names as a result of the wars that have since taken place.

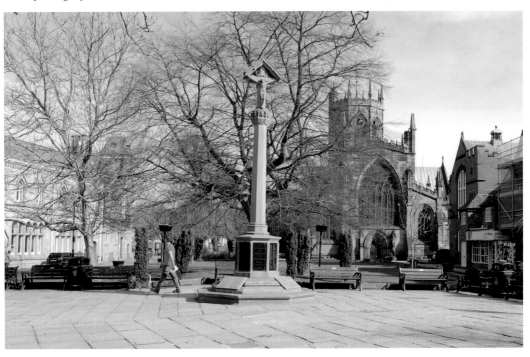

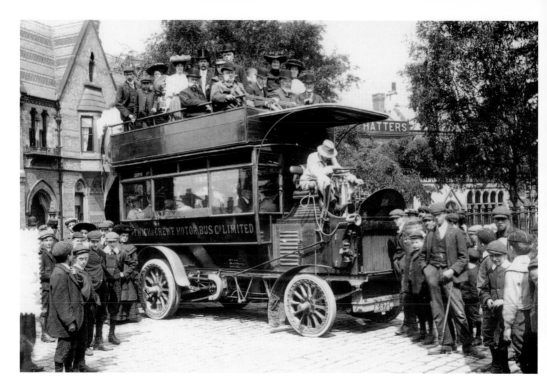

Town Square Bus early 1900s and 2010
The Town Square was the bus stop for the Nantwich and Crewe Motor Bus Company and its service between the two towns started in 1905. At the rear of the bus in the old photograph is the building that is now the Lloyds TSB bank. The solid rubber tyres on the bus would have made for a rough ride and as for the poor driver, he had to hope that it didn't rain!

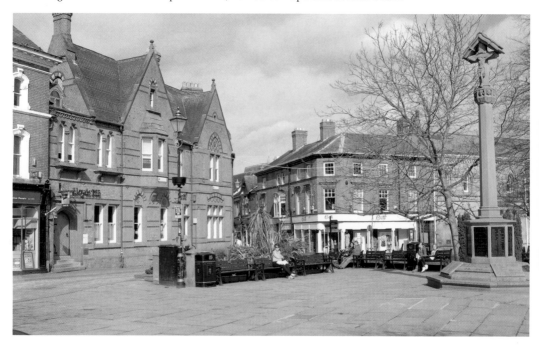

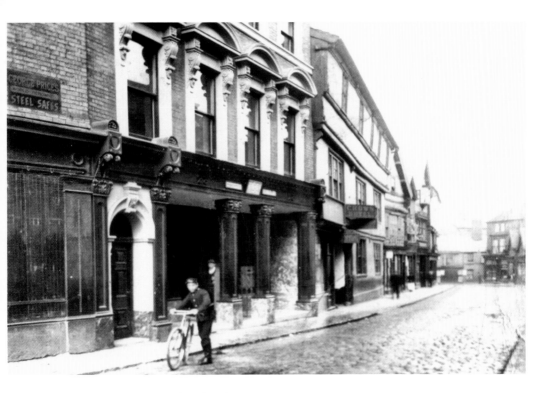

High Street Post Office undated and 2010
Looking down the High Street now towards the Crown Hotel we see the post office on the left with a telegraph boy and his bike outside. The building now houses the Savers shop and on the near left is an advertisement on the wall for George Price Steel Safes. Mr Prices traded from 96 Hospital Street as a cabinet maker, furniture and bedding manufacturer and carpet warehouse.

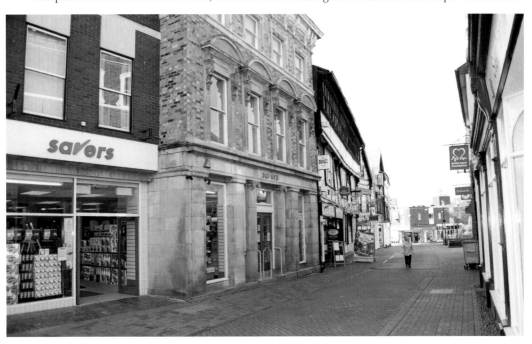

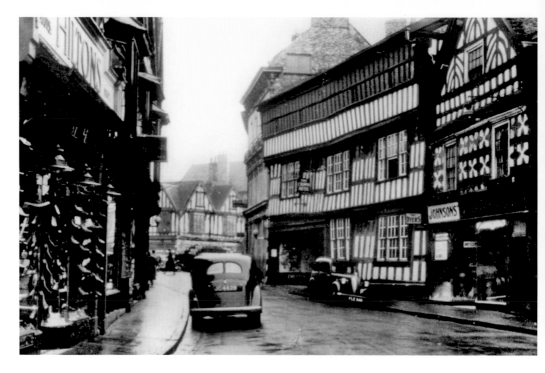

High Street Crown Hotel 1950s and 2010

Having walked down High Street past the ancient Crown Hotel, we turned and like the 1950s photographer, took a modern photograph. The Crown Hotel has changed little since the 1950s but then it has been there since just after the great fire in 1583! Once the principal hotel in the town it is possibly one of the most original Elizabethan buildings to be found anywhere. In 1902 the licensee was George Piggott, said to be an ancestor of jockey Lester Piggott. It was built on the site of an earlier inn, The Crowne that burnt down in the fire.

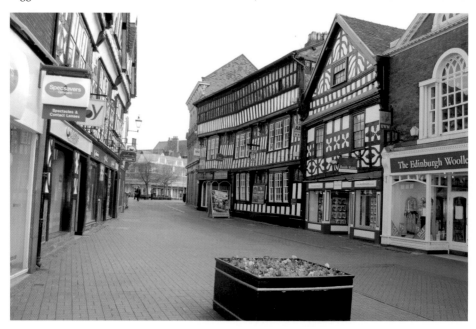

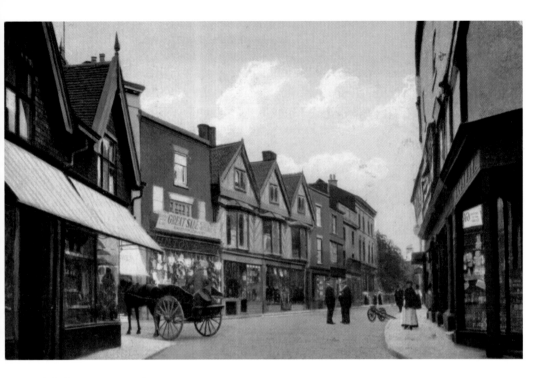

High Street 1909 and 2010

Continuing down High Street we come to a group of pitched roof shops that were demolished in 1959 but in this old photograph they can be seen on the far left. As can be seen, not a lot has changed here in the intervening 100 years and what has been altered has been done tastefully and in keeping with the original buildings. The Great Sale advertised is at Hiltons shoe shop where Mr W. E. Hadfield was the manager.

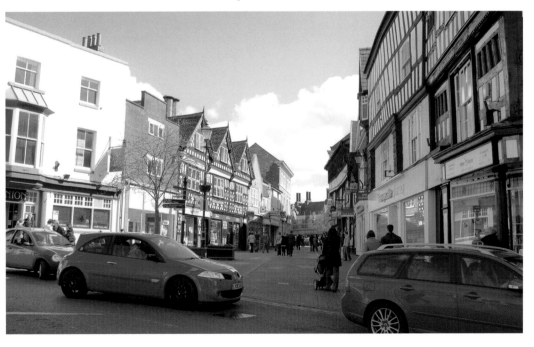

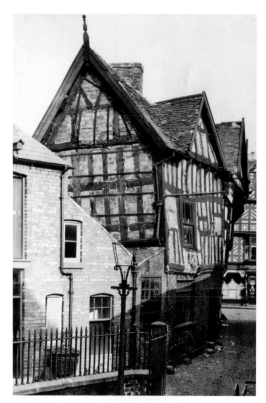

Bookshop side undated and 2010
This antiquated building houses The Nantwich Bookshop which is a well-known feature of the town but not many people will have see it from this angle, or rather they probably won't have noticed it. This shows that the side of the building is just as antiquated and quaint as the front albeit that a modern building now masks its full glory.

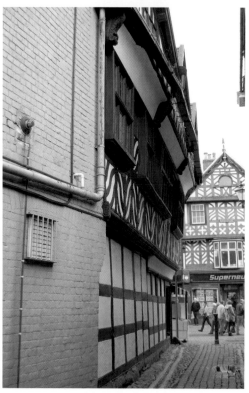

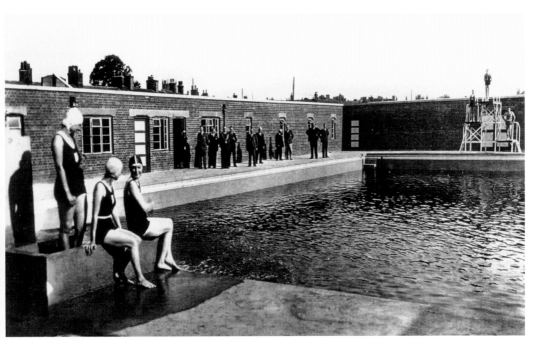

Nantwich Brine Baths 1931 and 2009

Nantwich Brine Baths have been there since 1883 albeit that they have been kept to a very good standard. The modern baths have been built on the ground vacated by the old Town Hall and the old baths incorporated into them giving swimmers in summer the choice of indoors fresh or outdoors brine. Note by the time the new photograph was taken in 2009 the doors and windows shown in the old photograph have been bricked up. The mayor in his regalia is watching the pretty bathing belles!

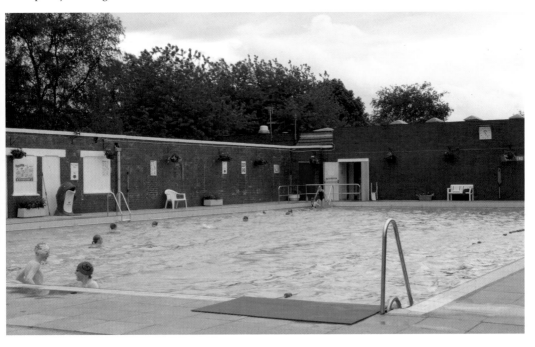

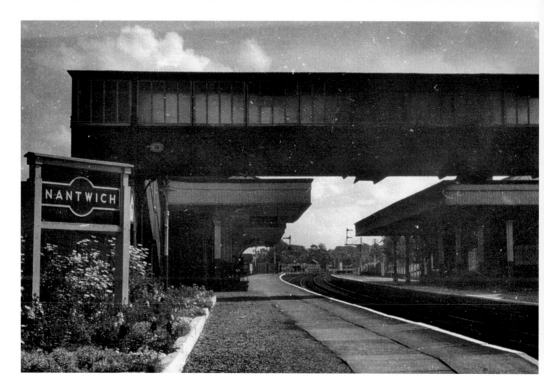

Station 2010 and undated

Nantwich station astride the line from Crewe to Whitchurch on the London & North Western Railway once had a Great Western Railway spur to Market Drayton. As befits a town of the importance that Nantwich was in the mid 1800s, it was given a quite impressive railway station. Not only was there a footbridge by the level crossing but also a covered footbridge between the platforms. This one can be seen in the old photograph together with the quite impressive station buildings on both sides of the track.

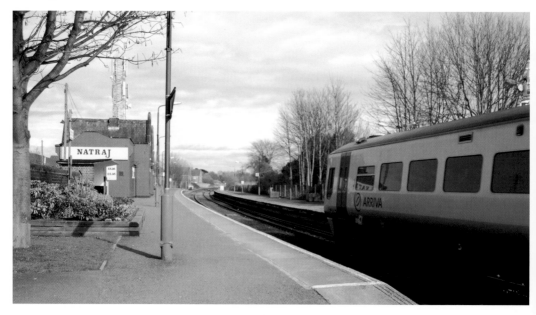

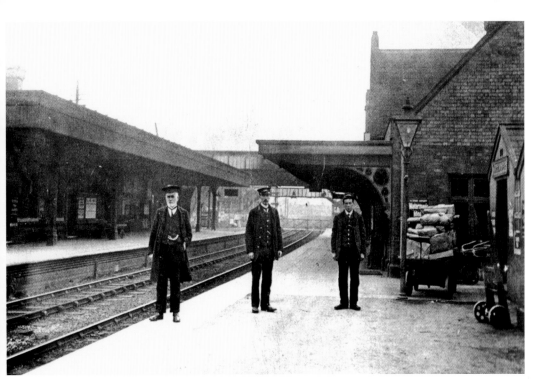

Nantwich Station 1912 and 2010

There are 100 years between the two photographs and they show how things at the station have changed. The crossing gates in the old photograph are closed as a train approaches from Whitchurch and the two foot bridges are clearly in view. The station master waits to greet the train and the porters stand by to carry the luggage. Mr Ratcliffe the gentleman in the centre.

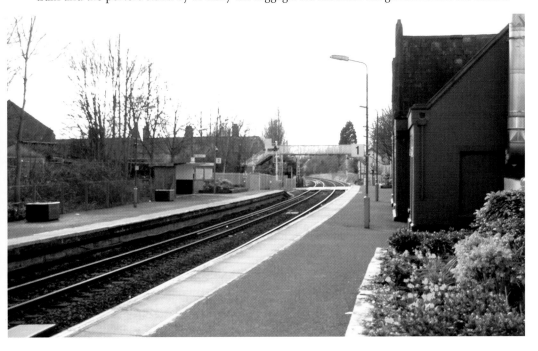

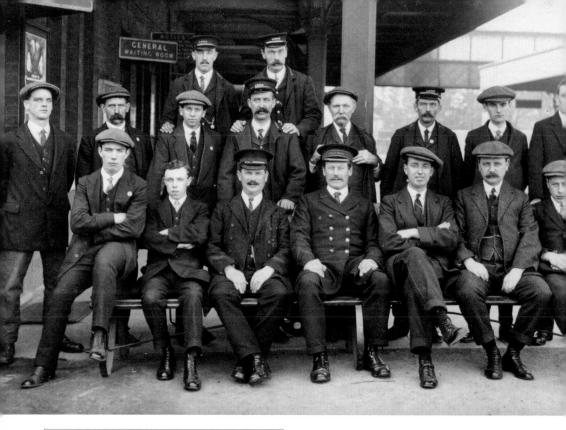

Station Staff 1920 and 1935 advert
Like similar small stations there was no shortage of staff, from the important station master in his fancy uniform to the boy who lights the oil lamps they are all in the old photograph. There are still staff working at the station but now they work in the Indian restaurant that has taken over the buildings on the Crewe bound side! The buildings behind the men have now gone and been replaced by a shelter. I have paired this photograph with an advert from 1935.

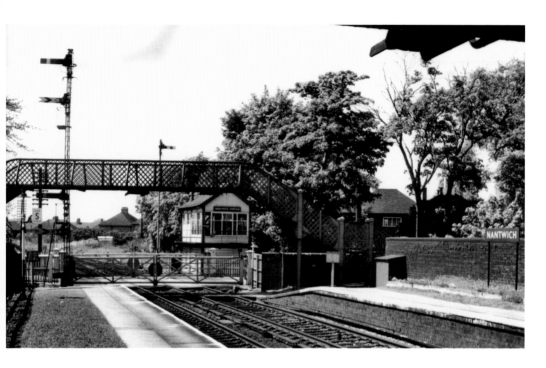

Station Signal Box undated and 2010

We take a last look at the signal box at Nantwich station and the footbridge over the lines. As with all level crossings there have been unfortunate incidents and Nantwich is no exception. One such occurred on 26 June 1964 when a train struck a car on the crossing. Mr George Eardley a hero from the second war was involved. As Sergeant George Eardley VC MM - 4th Bn, King's Shropshire Light Infantry he had been awarded the Victoria Cross and Military Medal. He had been invited to Copthorn Barracks for a presentation of colours by Princess Anne when the accident happened. His wife was with him and sadly she was killed, while he lost part of his leg.

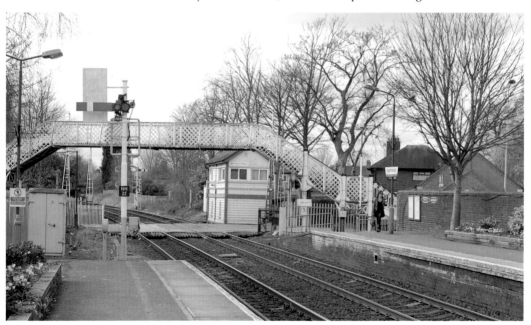

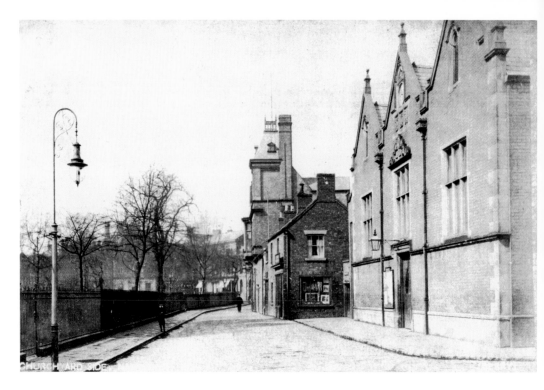

Churchyard side and Market early 1900s and 2010

We go back now to the town and a look at Churchyard Side where the buildings have been altered over the years. The market hall built in 1868 for £2,000 originally had three separate tiled roofs with a classical red brick front elevation to each one. Now this has been altered as you can see from the before and after shot. The building after the hall has gone and the one past that has lost its cast iron crown. Which vista do you prefer?

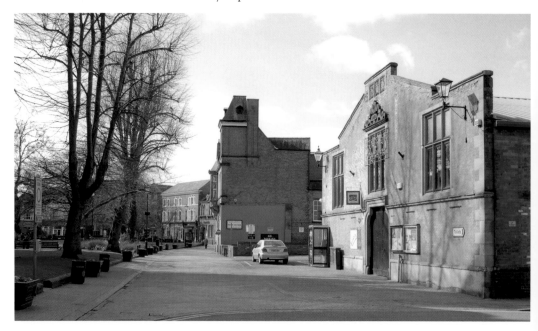

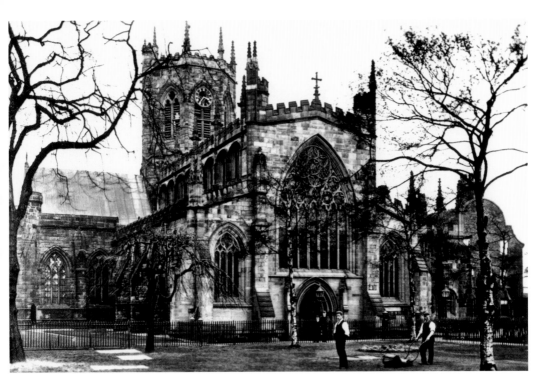

St Mary's church with gardeners undated and 2010
By the late seventeenth century the church had been altered and 'had undergone many changes by no means conductive to its beauty!' The decision was made to restore it to its original style, parishioners and gentry raised the funds and the eminent architect G. Gilbert Scott drew up the plans. Between 1855 and 1858 the church was returned to its original beauty. It even has a door knocker, quite unusual on a church door!

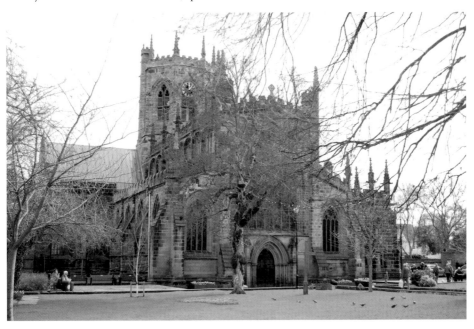

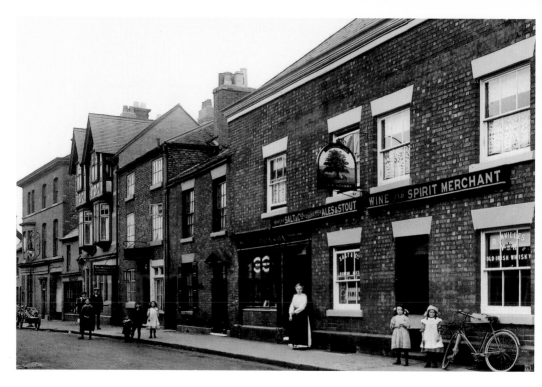

Royal Oak 1920s and 2010

We walk up Market Street now to Beam Street where once stood the Royal Oak public house, Beam Street boasted many public houses, the oldest is still standing, The Red Cow. But here we see the Royal Oak as it looked in the 1920s and what we have today; the small house next to it is now part of the Superdrug shop and the larger house further on has lost a floor. But the pub building is still there; or rather a new building built in a very similar way is there. Either way the old photograph is filled with period charm.

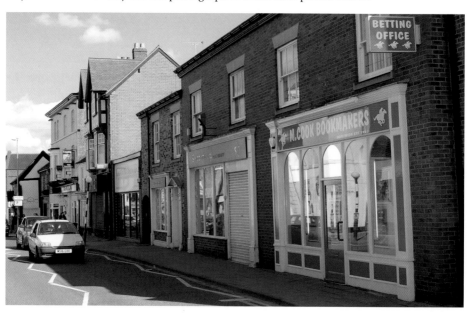

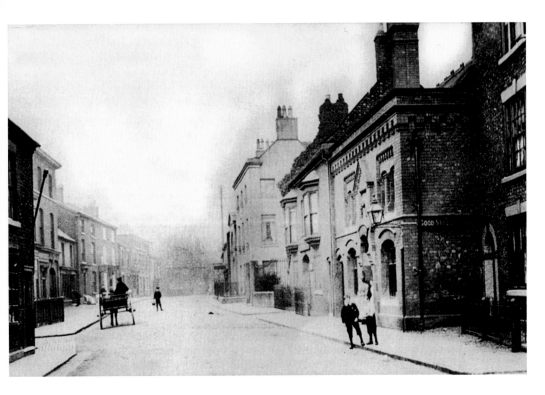

Beam Street 1800s and 2010

This is an ancient photograph of Beam Street showing what was there in the 1800s, the large white building that is now Mia Stanza is there but the shop at the end, later to become Moultons is still a house. Over the road, the Malbank pub can be seen. This pub is named after the Barons Malbank or Malbanc and a very early name for the town as Wich-Malbank; William Malbank was made Baron of Nantwich after the Norman Conquest.

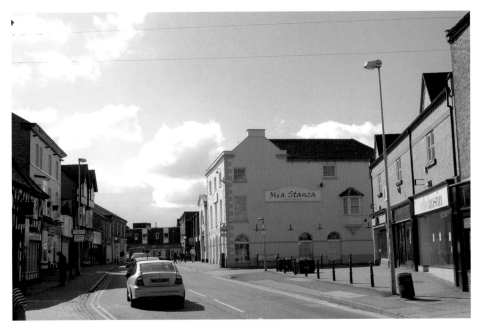

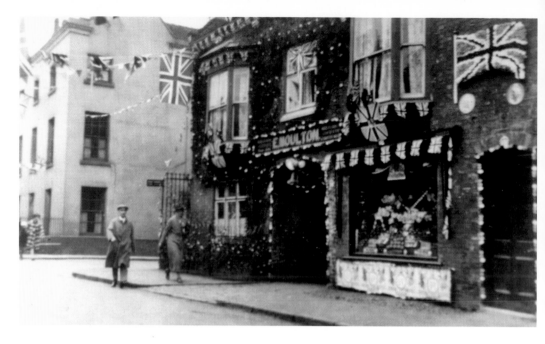

Moulton Beam Street 1937

I am dating this photograph as 1936 after viewing the evidence on the old photograph. The shop is owned by Enoch Moulton and is a greengrocer's decorated to celebrate the wedding of King George VI and Queen Elizabeth. This building was later demolished and the current one built. Beam Street was named after wood from Delamere Forest was carried along it to re-build the town after the Great Fire. As a modern photograph is overleaf I have twinned this with a period advert.

Enoch Moulton

Florist & Fruiterer.

ENGLISH RABBITS.

9, BEAM STREET,

NANTWICH.

☞ Town deliveries daily—may we give you a call. ☜

Speciality: WREATHS and CROSSES

AT SHORT NOTICE.

TELEPHONE No. 5122.

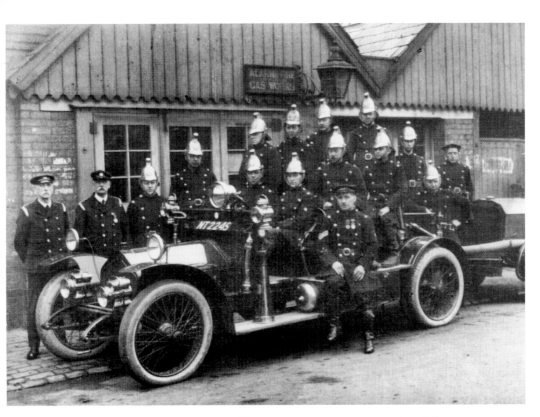

Nantwich Fire Service early 1900s and 2009

In the early 1900s Nantwich had two fire services, Volunteers and Nantwich Urban District Council Brigade. Both were based in Market Street where the old photograph was taken of the volunteer brigade. Their captain was Mr H. T. Johnson; the council brigade had Lt Col Thistlethwait in charge. There was a lot of competition between them until the town just had one brigade based where the police station is now. Later it moved across the road to its present location. The photograph of the present brigade was provided by the manager John Grocott who can be seen second from left front row.

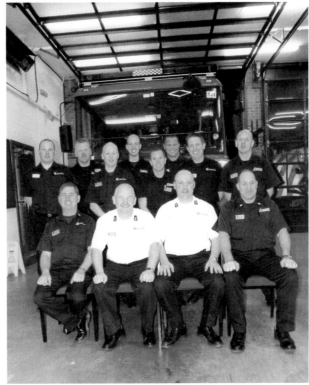

Congregational Chapel Monks Lane undated and 2010

The Congregational chapel was built in 1842 and still exists having been converted into luxury dwellings. In 1860 the Reverend Edward L. Adams was there and it was then called The Independent Chapel. The Sunday school building next door has been demolished to make way for a car park for the old chapel. The far gatepost to the Sunday school is still there.

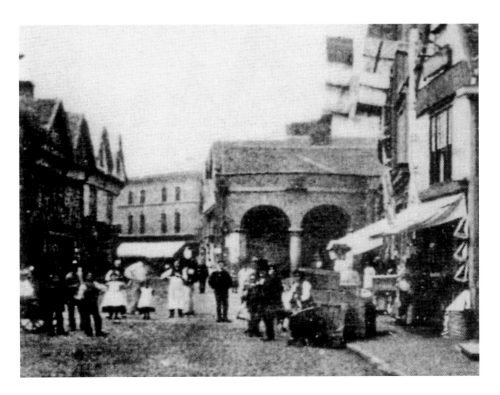

Buttermarket 2010 and 1860s

Now we go back to the oldest photograph in the book and the quality of it reflects this. The Market Hall that can be seen in the old photograph is a small building supported by granite pillars. It stands roughly where the outdoor market occasionally takes place today and the buttermarket was held there every Saturday. This Market Hall was demolished in 1868 when the new one was built in Market Street.

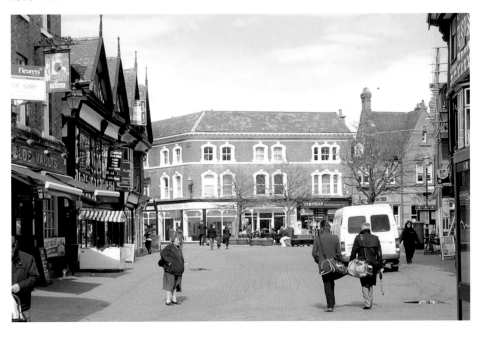

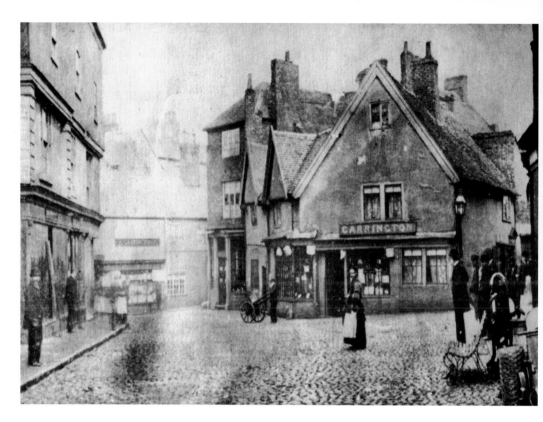

Carrington Store Hightown 1880 and 2010

Keeping the old photographs together we have here a photograph of Carrington's stationers at 11 High Street in 1880. This group of buildings are across what is now Beam Street leading down to the bridge. The area is called Swine Market.

Zan Store High Street 1920s and 2010
The Zan Haberdashery store was situated at the end in Hightown within the block of buildings numbered 13A and 13B High Street. In the distance can be seen the grocer's shop of Robert Dixon at number 13C High Street in the building that was once Carrington's stationers. That whole block of buildings was demolished in 1959 and far less attractive ones built in their place.

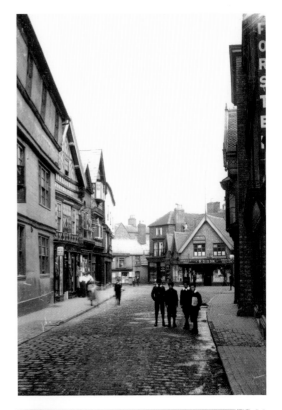

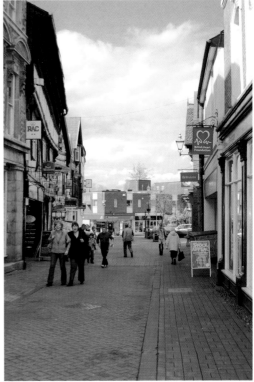

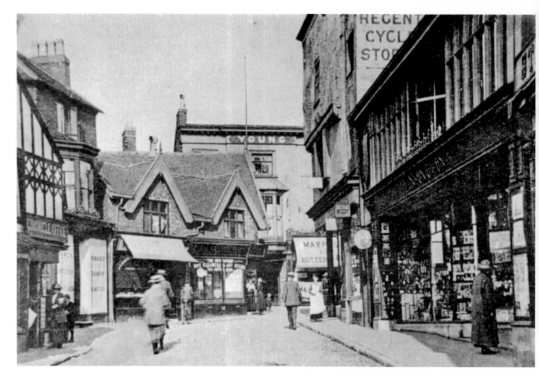

High Street 1915 to 1920s and 2010

Now we walk to the end of the High Street to the junction with what is now Water Lode and we look back towards the block of shops that would be swept away to make way for what you see in the new shot. This was in High Street until the road was re-aligned and then it became a continuation of Beam Street. In view is the Maypole Dairy Company at 17 High Street and Edward Henry Young wine and spirit stores at number 15.

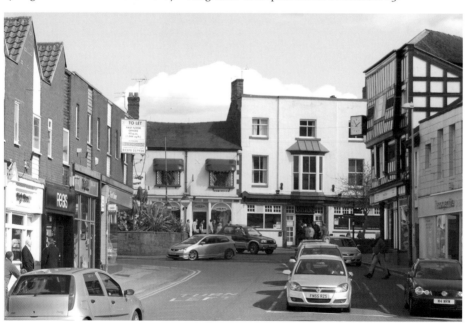

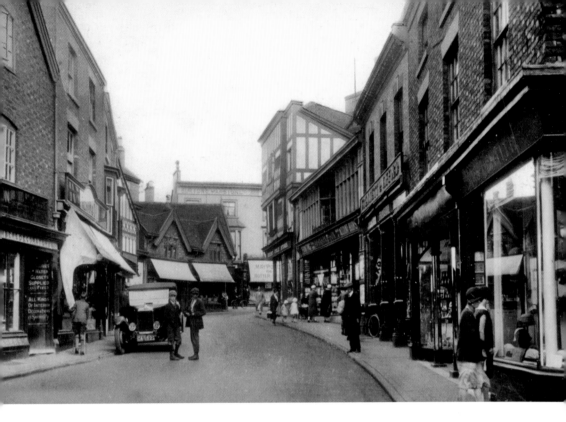

High Street cars late 1920s and 2010

Taken from a bit further back and on a later date we see the lower High Street, the Regent Cycle stores have now gone and the building updated. In the modern photograph all the buildings on the left have been knocked down and replaced with new ones after the road has been widened.

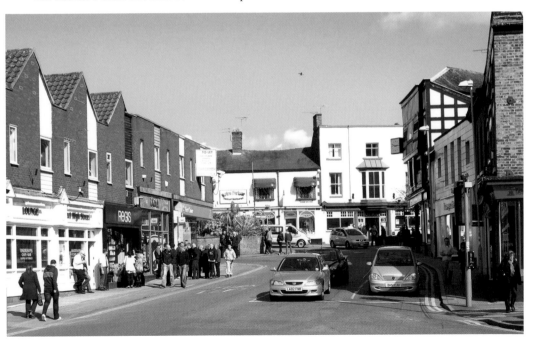

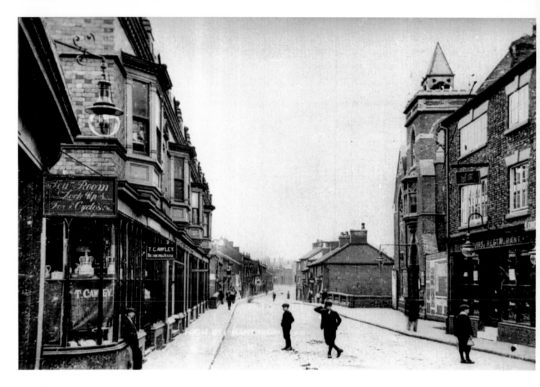

High Street to Bridge early 1900s and 2010

We now look down High Street towards the bridge and Welsh Row, with Thomas Cawley grocer to the left together with William Cawley's Tearooms. The advertisement on the wall is for the tearoom and as a lock up for cycles. This photograph has obviously been touched up in its long history, for is the boy in the middle of the road not leaning on something or someone that is no longer there? It was near this spot in 1583 that the Great Fire started by a Mr Brown brewing beer!

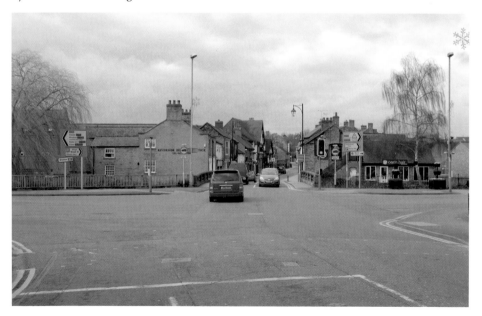

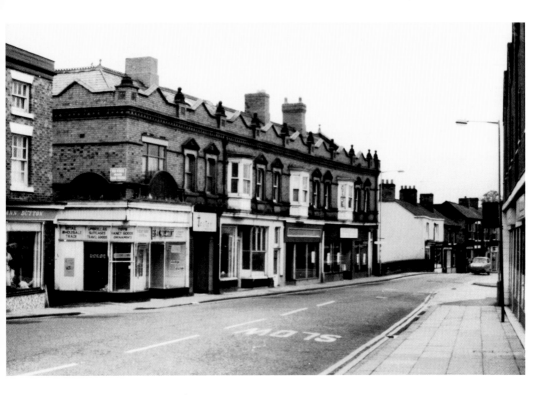

High Street shops 1970s and 2010

This row of shops once stretched from the present end building to the bridge as can be seen in the 1970s photograph. It was demolished to make way for Water Lode, the A530. The end shop in High Street on that side is the one with the name Ann Dutton on the left.

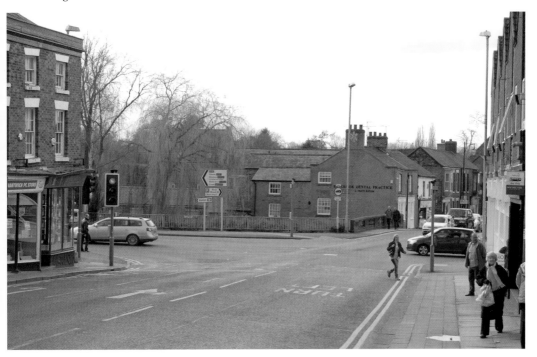

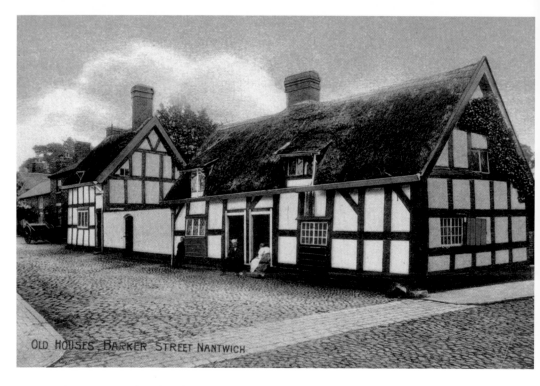

OLD HOUSES, BARKER STREET NANTWICH

Barker Street undated and 2010
We take a slight deviation here to look at the location of these quaint cottages in Barker Street, well, the card is marked Barker Street but they are in Love Lane really at the junction with Barker Street. They have now gone along with the adjoining houses and a more modern house has replaced them. Fortunately Barker Street has another ancient cottage for those interested to feast their eyes upon it.

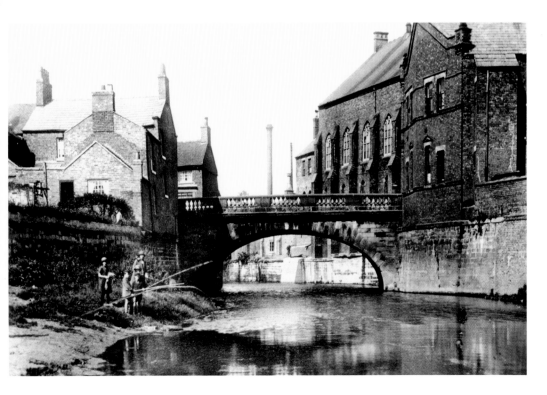

Nantwich Bridge Welsh Row 1910 and 2010

The single span stone built bridge dates from 1803 and it was built by William Lightfoot to replace a bridge that had been there since 1663. Tim Adams was the mason at that time, and there was also an even earlier wooden one. During coaching days this was the main road from London to North Wales and passes over the River Weaver. The bridge there was an important obstacle in the Siege of Nantwich during the Civil War.

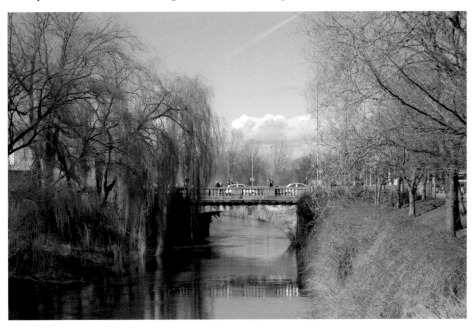

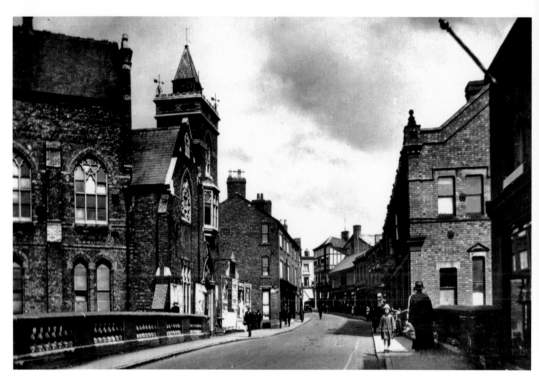

High Street from Bridge 1910 and 2010

Back now to the bridge and after crossing it we turn around and photograph the scene. The main building of note in the old photograph is the Town Hall on the left over the bridge. Built in 1803 at a cost of £2,531 over the years it incorporated The Corn Exchange, The Mechanics' Institute, The County Court and the offices of the Board of Health. It remained there until the 1960s when it was deemed unsafe and was demolished which was quite convenient really as that side of the street was being demolished anyway for road widening!

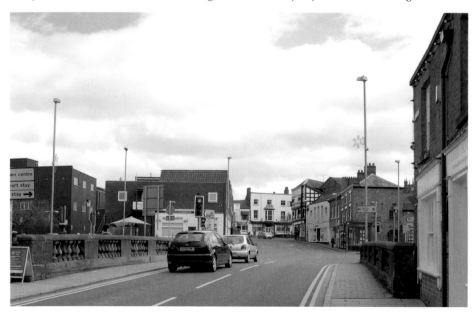

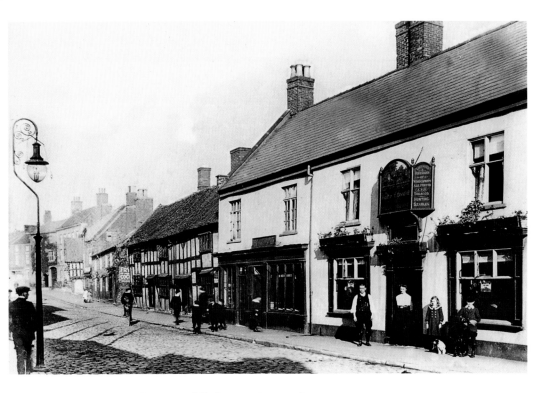

Welsh Row Three Pigeons public house 1800s and 2010

The pub was originally known simply as Pigeons in 1860 when Elizabeth Bayley was the licensee. Later on it became the joining point for the coach to Tarporley and Bunbury. There was a cockpit at the rear of the pub together with stables for the hunt. When the old photograph was taken Walter H. Goodall was the licensee. Between the old Three Pigeons and the Cheshire Cat are a set of sandstone steps. They were put there in the seventeenth or eighteenth century and were used by farmers' wives to alight from the back of their husband's horse. When taking the photograph an old lady pointed out that the top step was worn away by the butcher nearby sharpening his knives.

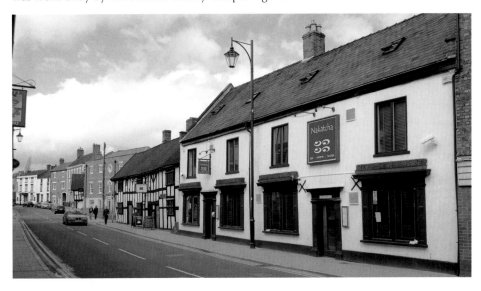

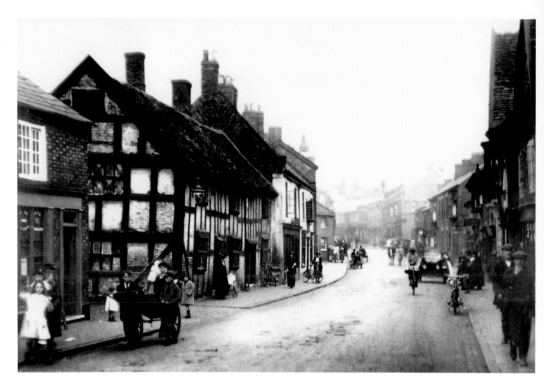

The Cheshire Cat Welsh Row 1920s and 2010

Founded in 1676 as an almshouse by Roger Wilbraham who endowed it with an annuity of £24 per year forever! The house was for the benefit of widows and it comprised three tenements of brick and wood and two widows resided in each. They received 17/6 per quarter and 6/8 per year for coal and once every two years were given a gown and a petticoat! Oh, also 'two old maids occupied a separate cottage.' The building went on to other uses and names as a nightclub and is now once again the Cheshire Cat Hotel Restaurant and Bar.

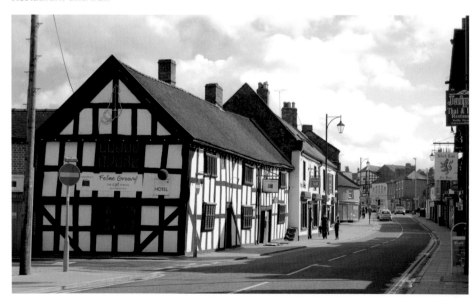

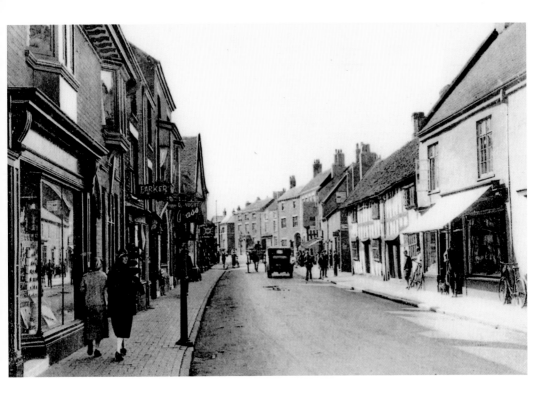

Welsh Row towards the aqueduct 1920 and 2010
A look now along the street with the Cheshire Cat opposite, this photograph is quite rare showing shops on this side of the road.

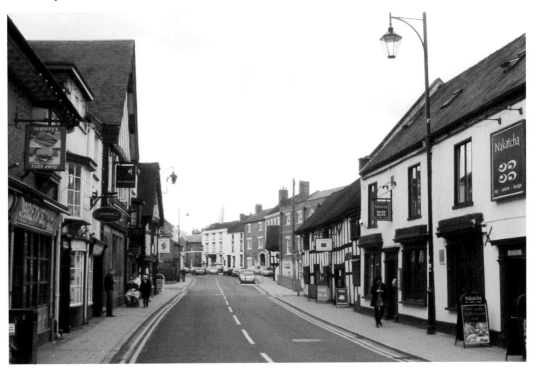

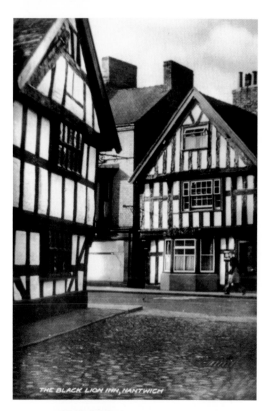

Welsh Row Black Lion Inn undated and 2010
This ancient pub, built in 1664 with a timber frame and brick and plaster infilling has, like the rest of the area, changed little over the years. It was for many years a coaching inn on the road from Chester to London.

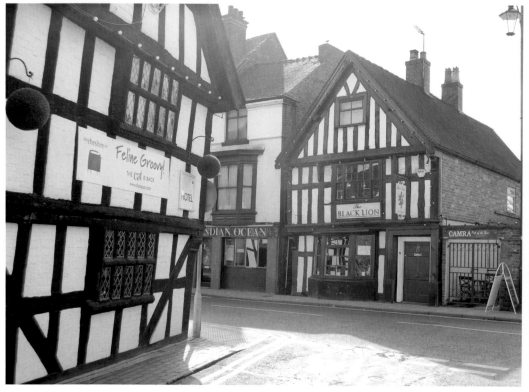

The Housewife's
Best Friend

GAS

Saves Time and Money.

A Gas Fire is the cheapest in any room where you don't want a fire all day. Turn the tap and your Sitting or Bedroom is comfortable.

A Gas Radiator warms your office or shop at the lowest cost without dust or dirt.

A Gas Cooker is indispensable, no housewife can do as well without it.

A Gas Boiler makes wash-day a pleasure especially if you finish it off with **A Gas Iron.**

For free expert advice write or 'phone us—5222.

We will come to YOU.

N.U.D.C.

Gas Dept., Welsh Row

**Welsh Row Black Lion Inn and Gas Alley
1934 and 2010**
Another look at the old Black Lion at the side of the pub is Gas Alley which led to the Nantwich Gas Works at the rear. Here also is an advert from the 1930s for the gas works.

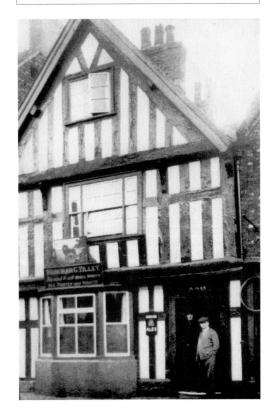

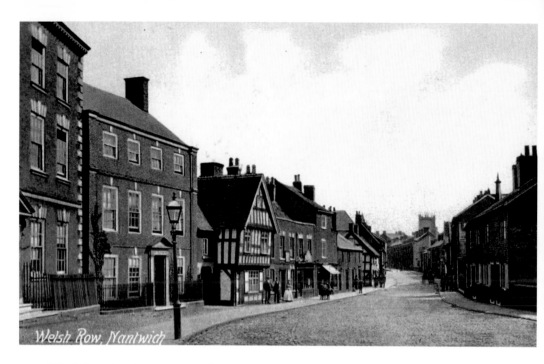

Welsh Row in colour 1900s and 2010

The name Welsh Row comes from the fact that the Welsh used to come into town this way to collect their salt. The road also avoided the Great Fire of Nantwich and it was called Frog Lane in the old days as there was an open drain from Welsh Row Head to the River Weaver; this drain was filled in 1865 when drainage replaced it. The black and white building is Tudor Cottage built in the seventeenth century or earlier.

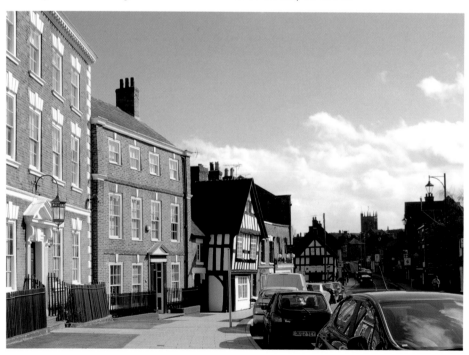

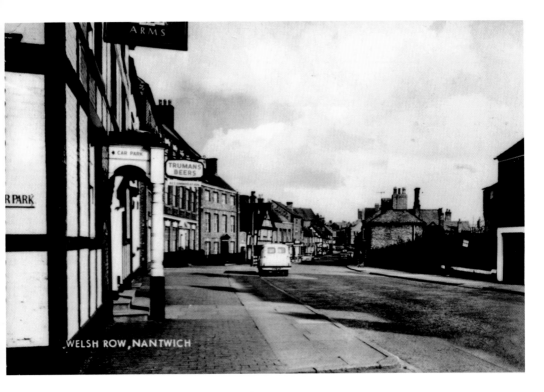

Welsh Row Wilbraham's Arms 1950s and 2010

Forward in time now and we see the Wilbraham's Arms pub on the left with its central porch supported by wooden posts. It dates from the late eighteenth to early nineteenth century and was originally called the Red Lyon. The present name was a tribute to Roger Wilbraham Esq. later Sir Roger who provided the two sets of Almshouses in the road, the Cheshire Cat building for women and the one at Welsh Row Head for men.

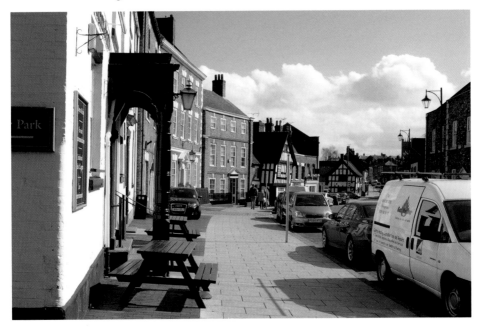

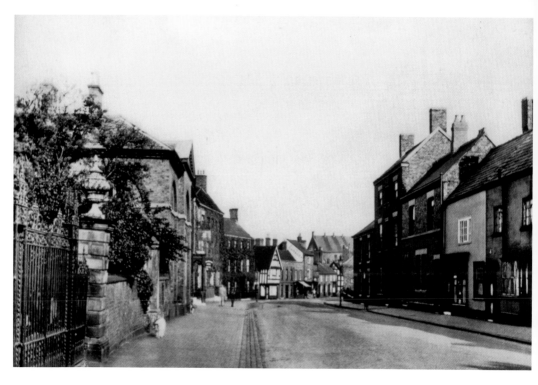

Gateway and 64 Welsh Row undated and 2010
We travel further along Welsh Lane now and pass two prestigious buildings. The first is The Gateway which was built in the early nineteenth century. It leads to Porch House that was once the home of the Wettenhall family, then in the early twentieth century it became solicitor's premises and a boarding school for girls. 64 Welsh Row is a beautiful eighteenth-century red brick town house.

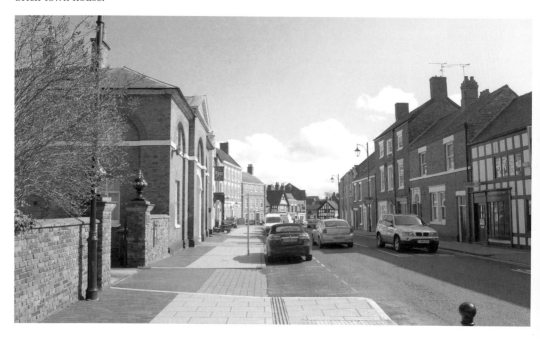

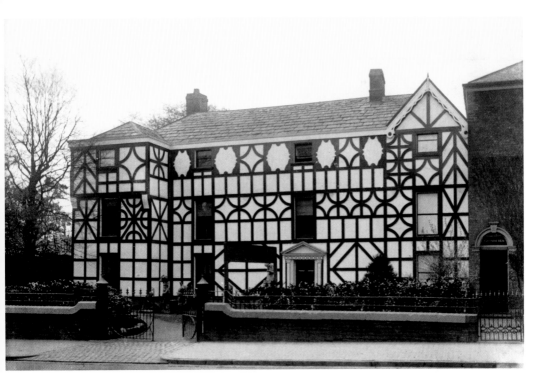

Whitehall 49 Welsh Row early 1900s and 2010
This too had been the home of the Wettenhall family in the seventeenth century and in 1902 Edwin Bayliss and his family were in residence and sold antiques from the house, by 1906 the name was Edward Bayliss. But as time went on it was allowed to fall into disrepair which eventually led to its demolition. The four houses in the new photograph were built on the land.

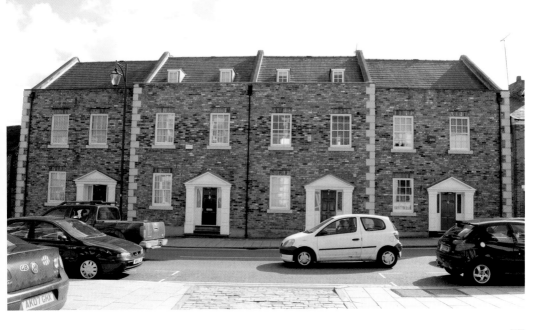

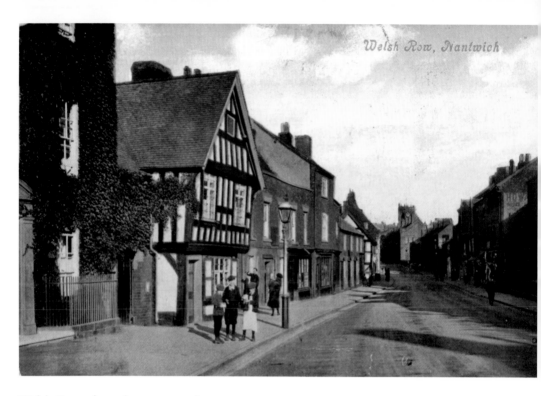

Welsh Row colour view 1900s and 2010

Another hand-tinted postcard looking at the Tudor Cottage in Welsh Row, there has been some demolition but not a lot of change in the 100 or so years between the two photographs.

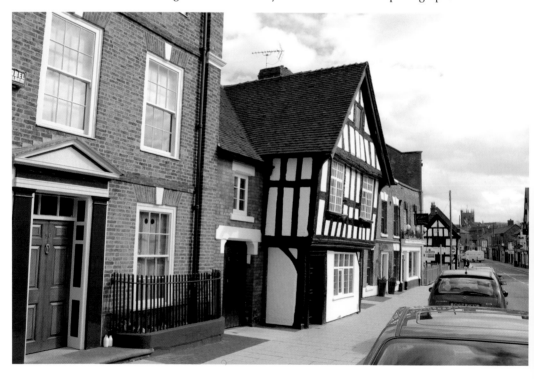

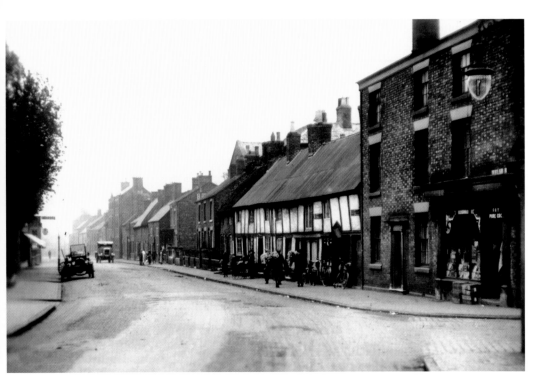

Welsh Row old cottages 1915 to 1925 and 2010
Carrying along Welsh Row towards the aqueduct we come to the junction with Marsh Lane and here stands a large shop premises that is still there. Unfortunately the pretty row of black and white cottages has been swept away with very little put in their place.

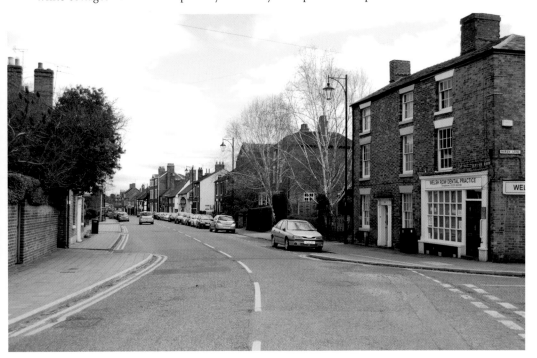

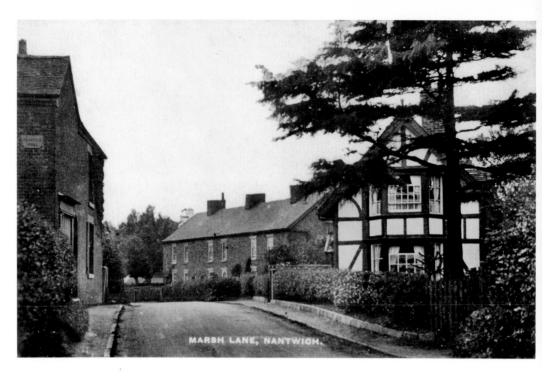

MARSH LANE, NANTWICH.

Marsh Lane undated and 2010

Turning into Marsh Lane from the three-storey shop we walk for a few minutes until we reach the black and white cottage on the corner and the row of old cottages a bit further on. The large redbrick house on the left is Crawford House and in 1902 it was the home of a Mrs Sutton.

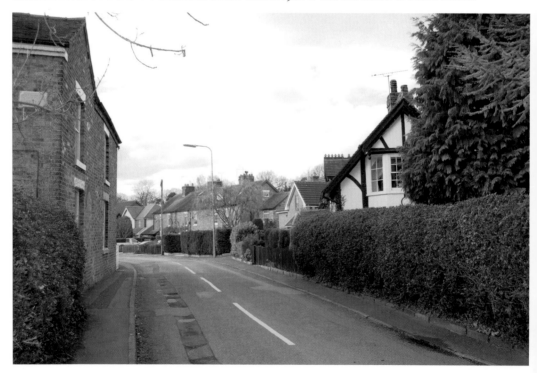

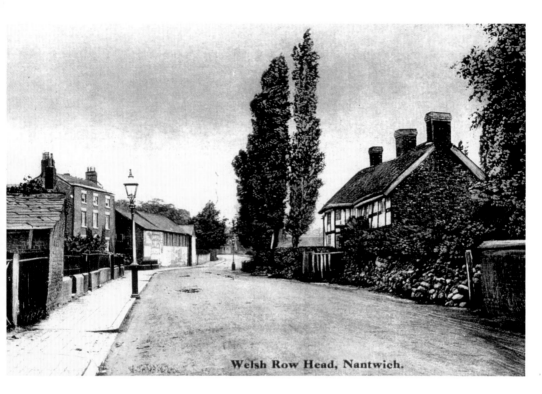

Welsh Row Head, Nantwich.

Welsh Row Head Early 1900s and 2010

The large three-storey town house in the distance is Tannery House at number 165 Welsh Row, one of the last buildings in the road. The resident in 1902 was Mrs Harriet Blud William and her occupation was Fellmonger, which means a dealer in hides or skins hence the name Tannery House.

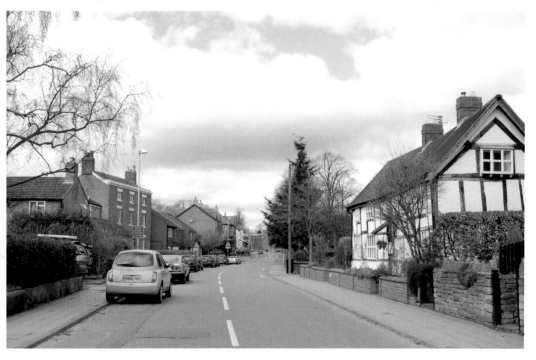

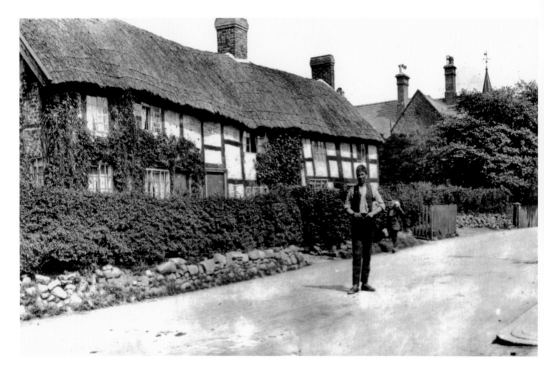

Welsh Row Almshouses undated and 2010

This row of black and white almshouses built in 1676 was provided by Sir Roger Wilbraham for six poor men, his later almshouses for poor widows are now the Cheshire Cat. This building was split into six compartments and when one became vacant the descendents of the founder would allocate them on the recommendation of 'some of the respectable inhabitants!' In 1870 another block was built next door to replace these, the buildings are still there on the aqueduct side.

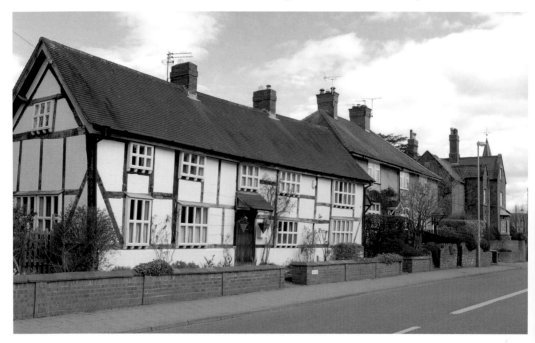

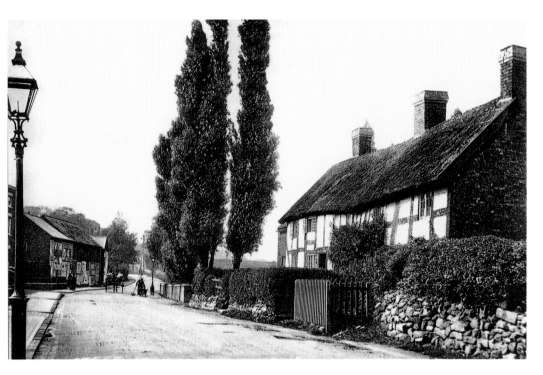

Welsh Row Almshouses early 1900s and 2010

Another look at the almshouses from the opposite direction and four of the inmates should be appointed from the inhabitants of Nantwich and the other two be natives of nearby Acton. The men or almspeople were to receive 10/- every quarter, a pair of shoes every Christmas and various articles of clothing once every two years to the sum of £14 6*d* each from the agent of J. Tollemache Esq. the houses now form one very pretty dwelling.

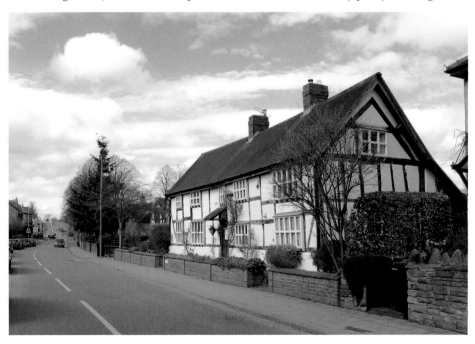

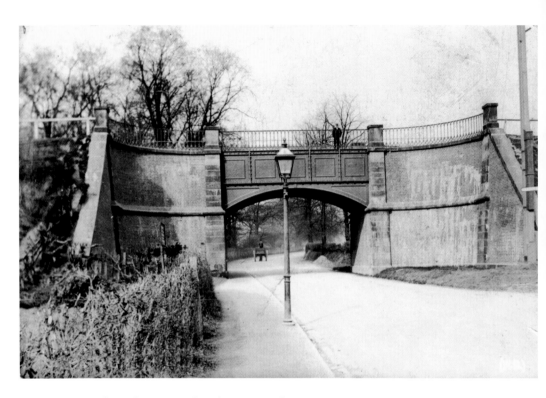

Nantwich Aqueduct Chester Road early 1900s and 2010
This aqueduct was built in 1826 by Thomas Telford to carry the Shropshire Union canal over Chester Road. It was constructed in cast iron with a water trough and cast iron balustrade.

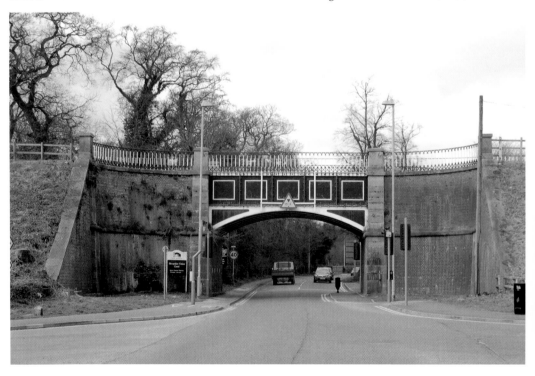

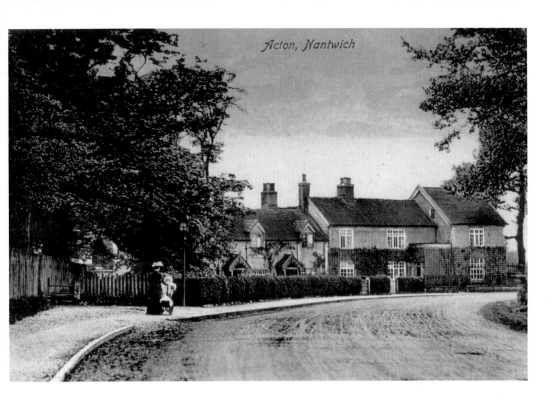

Acton Welsh Row Bend 1900s and 2010

Here we carry on under the aqueduct towards Chester, called Welsh Row Bend but was well into Chester Road and the last turn before the village of Acton.

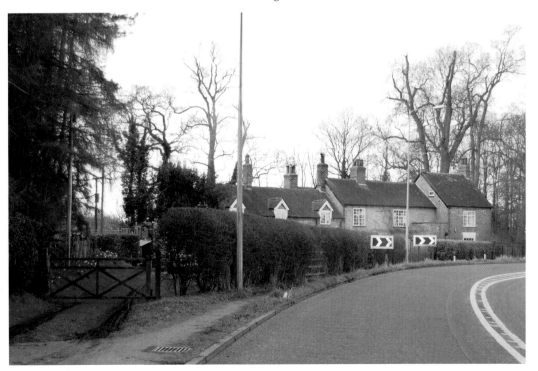

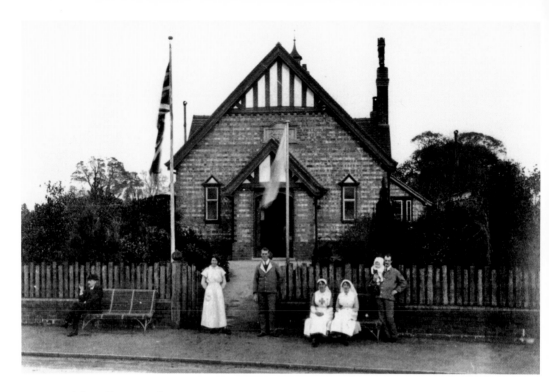

Acton Parish Hall 1917 and 2010

The Parish Hall was built by local subscription in 1909 and at the time of the older photograph it was being used as an auxiliary hospital in the First World War. Twenty convalescents resided there. In the second war Acton was home to evacuees from Liverpool and US troops were based at nearby Dorfold Hall. It was bombed by the Germans in 1940 but with no fatalities.

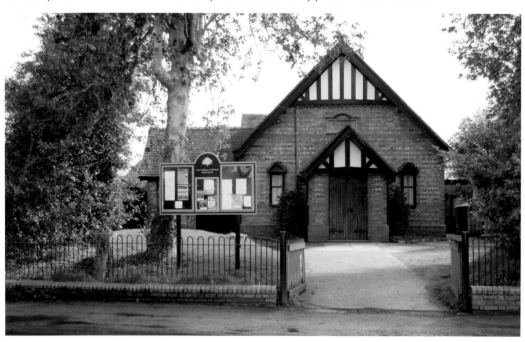

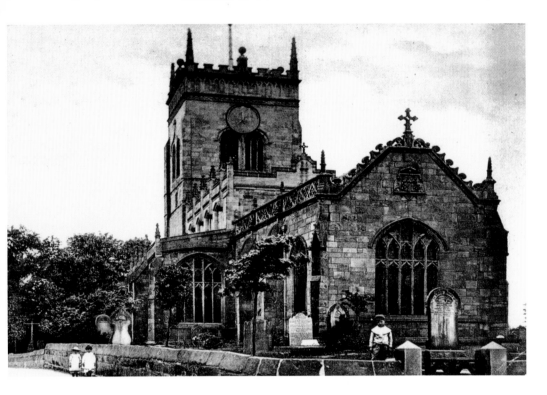

St Mary's Church Acton 1800s and 2010

The little space for descriptions cannot do justice to this important Grade 1 listed building. It is mentioned in the Domesday Book, about 1087 and vicars are listed from 1288. It became the mother church for Wrenbury, Minshull and Nantwich. It was here in the Civil War that the Royalists fired into Nantwich during the siege and where the final battle was held. Nearby was the abbey of Combermere and in about 1180 when building there was complete the monks started work on their church at Acton. Forty years before, there had been a great Welsh raid, and very likely this had left the old church building in ruins.

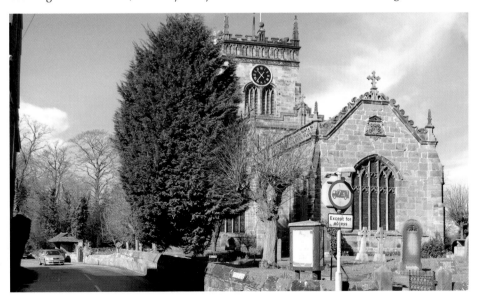

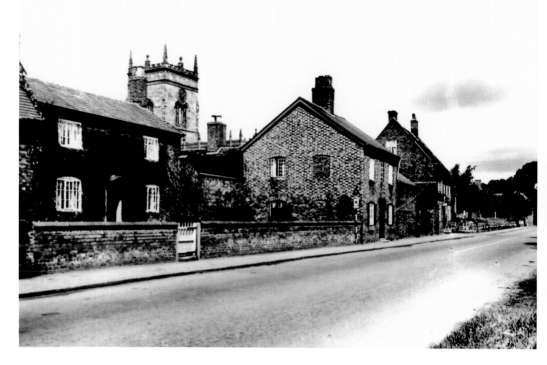

Acton Village undated and 2010

We now reach The Star Inn and look back from whence we have travelled; the old buildings on the opposite side of the road have changed little over the years. It is undated but with the crossroads sign and white line on the road I would estimate that it is the 1940s or '50s.

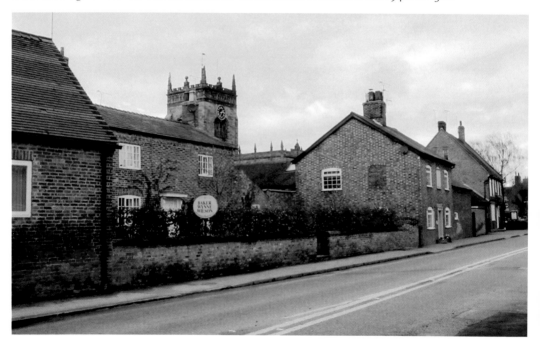

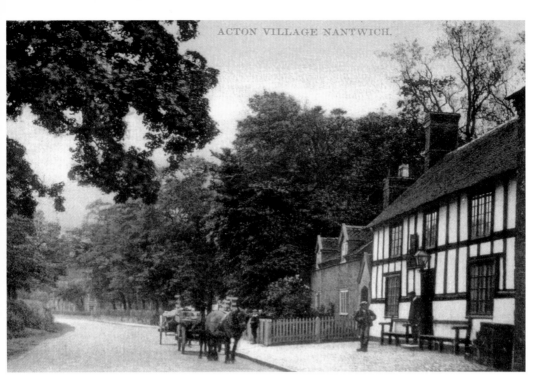

The Star Inn at Acton 1900s and 2010

Now in the pretty village of Acton and a look at a photograph of the Star Inn dated at the turn of the last century. This inn dates from 1590 and in 1902 around the time of the photograph George Boughey was both the landlord and a farmer. Acton means *Actune* or *Oak Town*, Delamere forest actually reached this far at one time.

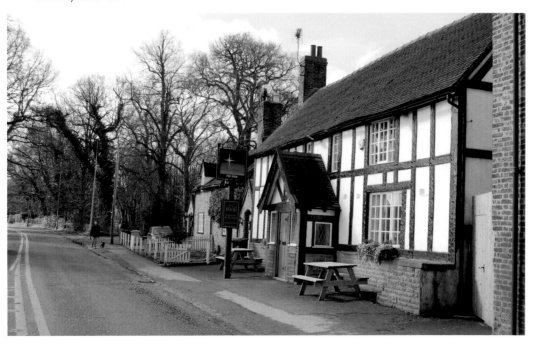

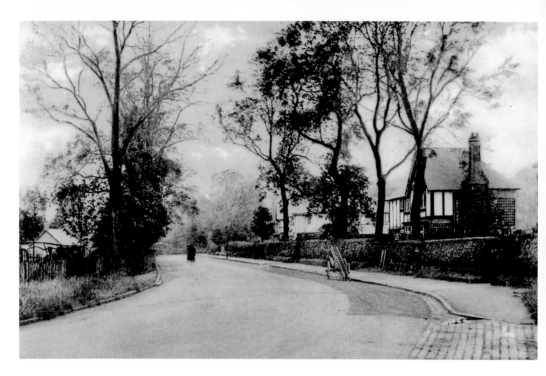

Broad Lane 1900s and 2010

Let us now have a look at some of the suburban roads, firstly we take a trip past Nantwich station, along Wellington Street and into Broad Lane which leads to Whitchurch, but here we look back at the road as it was in the early 1900s. The large house in the foreground has not changed much over the years other than losing its fence and the road is a lot quieter. The window cleaner has left his ladder and cart at the side of the road and a man perambulates leisurely down the centre of the road with his barrow.

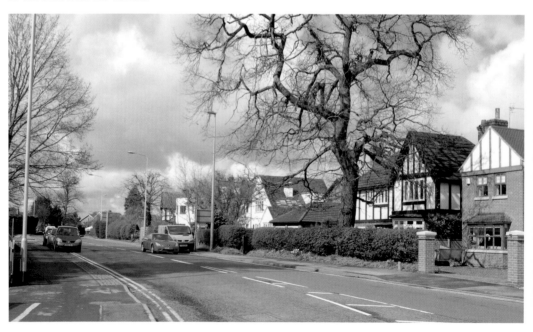

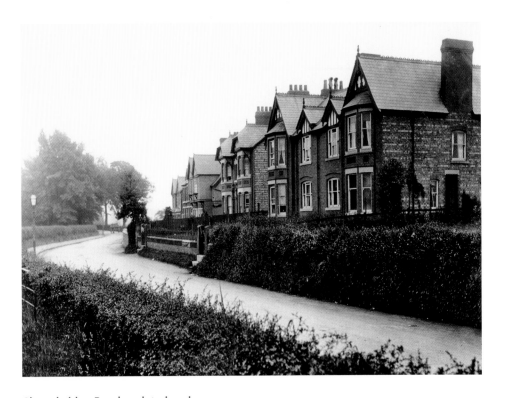

Shrewbridge Road undated and 2010

Now a quiet suburban street, the hedge over which the cameraman in the old photograph has pointed his lens has now gone but the grassed area is still there. This was a long and important road leading to Whitchurch and was once a continuation of Barker Street until it was dissected by Water Lode, the A530. Later on towards Whitchurch it will again become the main Whitchurch road.

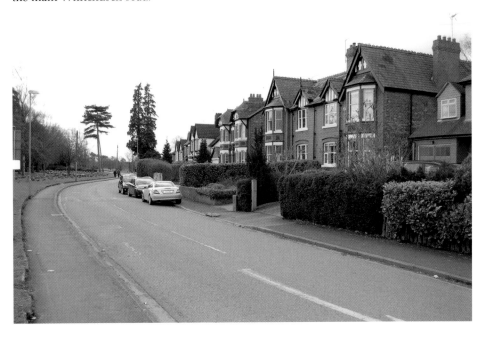

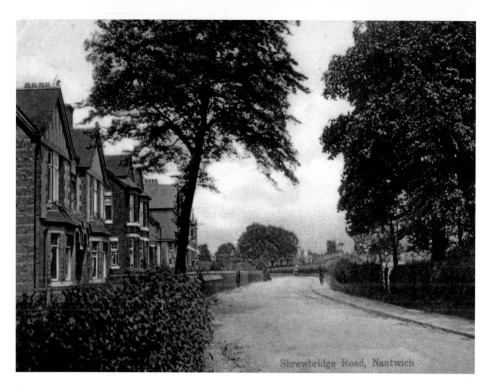

Shrewbridge Road, Nantwich

Shrewbridge Road in colour 1911

Travelling down this now by-passed stretch of Shrewbridge Road we turn and look back along the road using a 1911 tinted photograph. The church tower can be seen in the distance; trees hide it in the modern photograph.

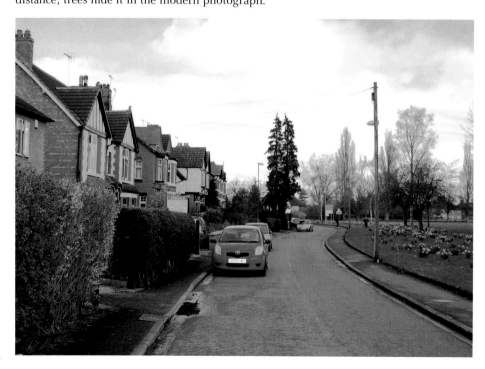

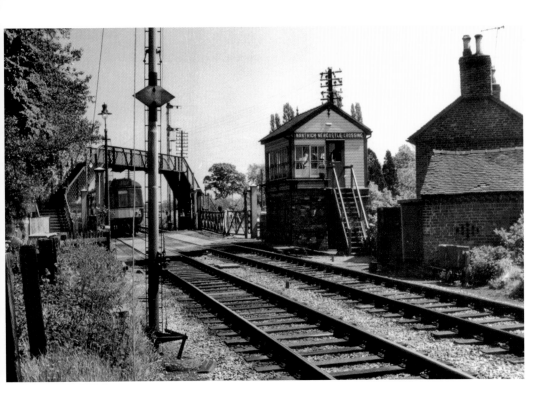

Newcastle Crossing 1950s and 2010

This crossing of the Whitchurch Road has lost its signal box and foot bridge, and the need for a footbridge baffles me. Even when it was built surely pedestrians could wait for the train to pass, I suppose 'Elf and Safety' had a place even then! The old photograph is dated the 1950s but that will be incorrect, it will be at least the 1960s as in the 1950s the diesel railcar will have had a cat's whiskers logo on the front, not the yellow panel that came later.

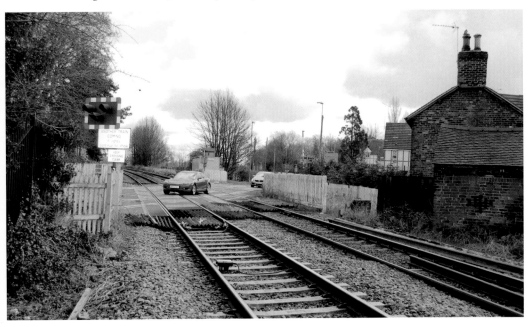

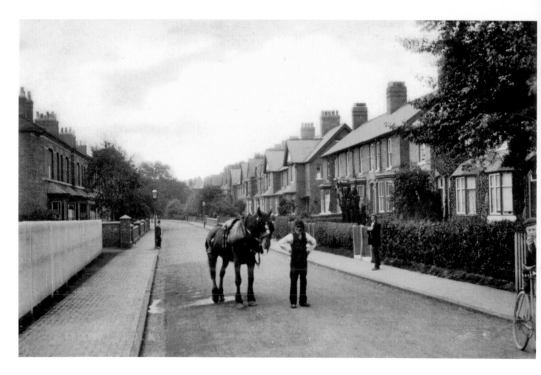

Wellington Street 1910 to 1920 and 2010
An extension of Pillory Street, Wellington Road passes the railway station and crosses the level crossing. The old photograph dated at the start of the last century shows a man with his horse, the horse seems to have been taken short! Little has changed in this road from here on but road changes have affected it at the Nantwich end.

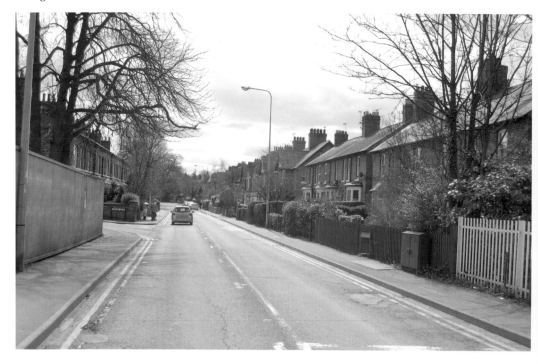

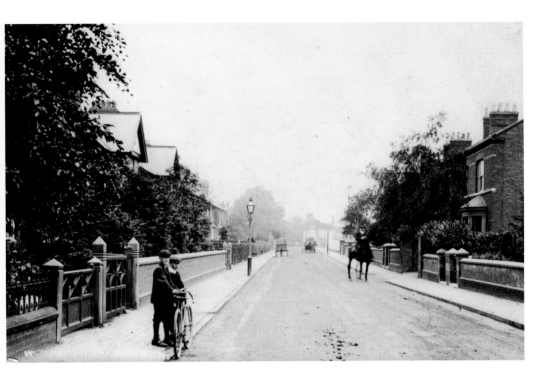

Wellington Street towards the Station 1900s and 2010
We travel further into Wellington Street and turn to look back towards the station. The white fence can be seen in the distance as seen in the last shot. The two boys have a period racing cycle; a man sedately rides down the road and behind him a heavily loaded lorry behind a dray horse.

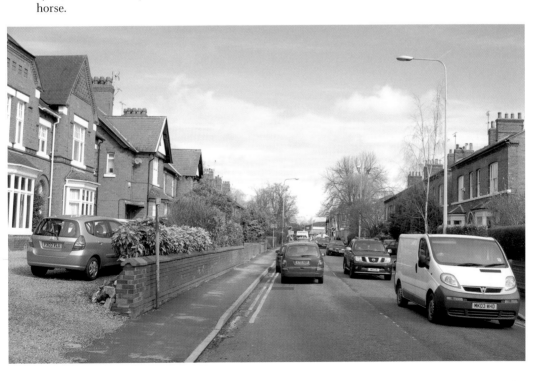

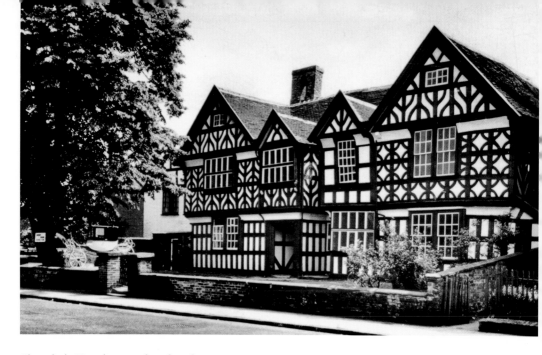

Churche's Mansions undated and 2010

What better way to end this look at *Nantwich Through Time* than to show the most famous building here, Churche's Mansion, built in 1577 and as such is one of the oldest buildings in Cheshire. It escaped the Great Fire and, had the fire travelled further, this ancient building would have only lasted six years! It was built by Richard Churche who was born in 1540 and married Margerye Wright, the daughter of another important family in the town. Richard had come from Leicestershire, become wealthy and had the Mansion built for him by Thomas Cleese or Clease, a master carpenter who also worked at Little Moreton Hall. It has had various uses over the years and is now an antique shop.

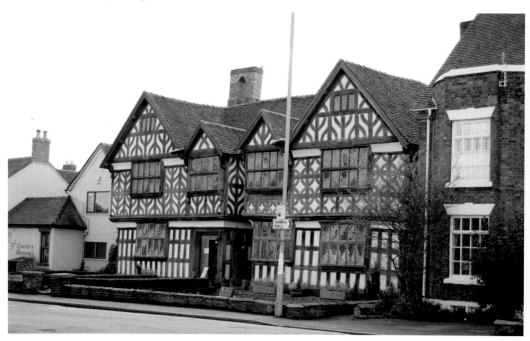